Medium Format Film Photography

Jeff Stefan

Table of Contents

Why Film?	4
Why Medium Format?	10
Medium Format Cameras	13
Pinhole Cameras	27
Essentials of Film Photography	38
How To Use Your Camera	41
Light Metering	47
Shooting and Composition	55
Developing Negatives	65
Photographing Images Digitally	77
Great Black and White Photographers	87
Final Thoughts	96
About the Author	97

Copyright © 2019 Jeff Stefan
All images and photographs © Jeff Stefan.
Cover Photo: Violin, shot with a Yashica Mat 124G
Published by J Stefan Photography
All rights reserved.
ISBN: 9781792726293

Why Film?

Film is dead, right? Not by a long shot. Many 35mm film cameras are still made and sold. Hardcore street photographers all over the world still carry multi-thousand dollar Leica rangefinders that use 35mm film. Many fine art, gallery quality photographs are created using 6x6cm or 6x4.5cm medium format cameras and 4x5in or 8x10in large format view cameras.

Images made from film are visually rich and continuous, and the good news is that film photography is experiencing a resurgence. Why? I believe it's the appeal of the process. It's much more than just snapping shots in Auto mode on a digital camera and uploading them to a computer. Shots are composed, metered, exposed then the negatives are developed and final prints are created from the negatives. Every step of the way requires skill.

In the end though, it's all about the final image. Great black and white prints created from film are deep and silvery. There's a profound sense of artistry associated with them. If the image is really effective you can tell what the photographer had in mind and what response he or she wanted to elicit, from their initial concept to the final image.

I'll spend a long time respectfully gazing at a good silvery print shot by one of the masters whenever I can. It's hypnotizing and enlightening.

There's also a timeless aspect to film photography that is hard to replicate with a digital camera. Like sailing, film photography is deeply linked with history. Every time you set sail or expose an image with your film camera, you're an active part of a historic and graceful lineage. You're a practitioner and student of the skill and craftsmanship required in every step of the film process. You are linked with what other photographers have practiced for over a span of two hundred years.

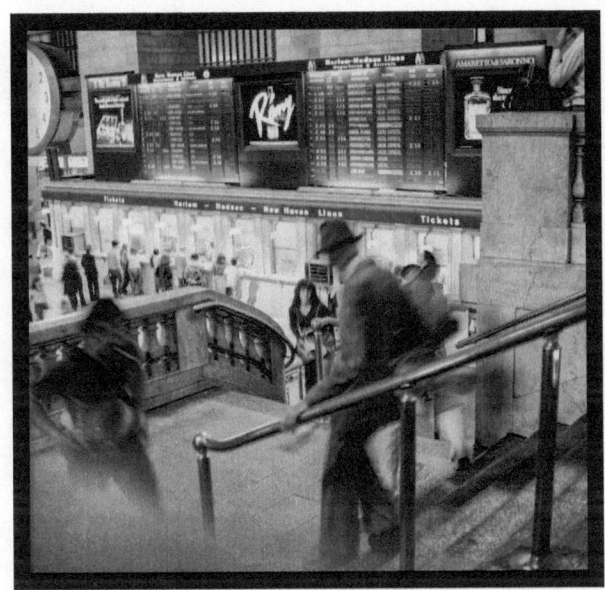

Yashica Mat 124G, Tri-X ISO 400

The Film Experience

Shooting with film is a totally different experience than shooting digitally. It's a mixture of art and science- chemistry to be exact. More than anything else, it slows down the process of creating an image, from taking the initial exposure, to developing the negatives, to creating a finished print. Every step of the way involves time, temperature, chemistry and light, especially if you decide to develop your own negatives. For me, it's a lot more disciplined, thoughtful process which I deeply respect, and I'm a digital photographer in my daily work.

With a digital camera, a photographer can fire away and upload hundreds of shots to a computer, sort the good from the bad, then move on to image post-processing. A lot of photographers call this "spray and pray."

There is no instant gratification when shooting film. There is no "spray and pray". Why is that?

First, let's consider the cost of film. Film is expensive. At this writing a roll of Kodak 120 TRI-X black and white film costs around six dollars for a roll of 12 exposures. A five pack of 120 TRI-X goes for around thirty dollars. You can buy a good SD or Compact Flash card for your digital camera for that amount and fit thousands of exposures on it, reformat it, and fit thousands more, ad infinitum. For thirty dollars worth of film, you get sixty exposures at best.

The Artistic Aspect

Next, there's the artistic aspect. Time decelerates when shooting film, because the whole process is slow compared to digital shooting. I believe this helps you to think about and be more deliberate with composition before shooting. The visualization experience is very different. There's something out of the ordinary and fresh about looking through a film camera view finder, because with some cameras what you see is not necessarily what you get. For me, composing a shot with a film camera, especially a medium format film camera with a waist level focusing screen, is a real thrill and link back through time, especially if you shoot in black and white.

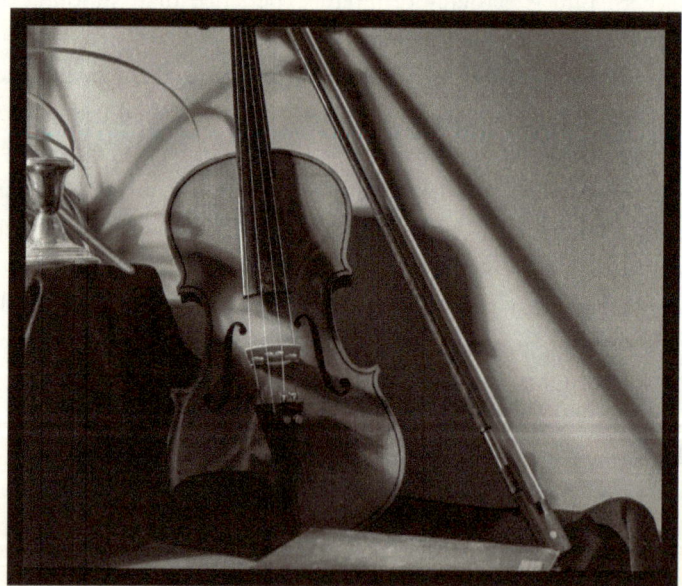

Yashica Mat 124G, TRI-X ISO 400

Is medium format film photography for everybody? Certainly not. But, if you're the type of photographer that deeply admires and is compelled to produce photographic art, medium format film photography may be just the medium for you to best express yourself.

Moving to Medium Format

When I started shooting, most photographers I knew were using 35mm rangefinders or SLR (Single Lens Reflex) cameras, including myself. So why move to medium format? There's a principle in film photography: the larger the negative, the better the quality the image. The next step up from 35mm film cameras and one step below 4x5in view cameras are medium format cameras. Medium format cameras vary in size and form, but commonly use 120 film.

As I said, I work as a digital photographer but I learned the basics of photography using a 35mm film camera. My first good camera was a Canon F1, which, aside from TTL (through the lens) match-needle metering, was completely manual. That's the way I liked it, having complete control over the exposures. In this book, all of the exposures were taken in Manual mode since that's usually the only mode available on older medium format cameras.

I loved my Canon F1, but like a lot of photographers, I wanted to get larger negatives and richer images than what was achievable via 35mm film. I moved up to medium format and started with a TLR (Twin Lens Reflex) camera. It was truly stepping into another world.

A Note About the Photographs

Underneath each image in this book is a description of the camera used along with film type. Not all of the photographs in this book were shot on a medium format film camera. For example, the cameras themselves and processing equipment were shot with a DSLR.

A Hybridized Approach

We will merely touch on making prints with an enlarger. This may tick off purists. I've developed hundreds of prints over the years using an enlarger. There's nothing like seeing an image emerge in a developing tray after you've spent a lot of time experimenting with exposure and dodging and burning a print. That being said, using an application such as Lightroom is a modern, efficient and effective way to create outstanding black and white images.

Photographing negatives or scanning them and processing the resulting

images in Lightroom produces spectacular results. All of the images in this book are from photographed negatives. It's pretty easy to photograph a negative with an inexpensive light box and the results are good. This book shows you how and what type of lenses to use when shooting negatives.

Another method is scanning negatives with a dedicated negative scanner. This is a common technique for preparing to process images from film negatives in software. Personally, I like the look of photographed negatives and there's an added advantage of shooting them in RAW mode with a DSLR, which we will cover.

We will go over methods to convert photographed or scanned negatives to positives in Adobe Lightroom. I believe Lightroom is the easiest and best path to converting negatives to positives and to post process images in preparation for presentation or print.

Again, this is a hybridized approach to film photography and is not pure, but it's convenient, contemporary and produces excellent results. If you have the space, time and desire to eventually produce prints with an enlarger in a darkroom setup you will always have your negatives, and they last just about forever.

What You Will Learn

This book teaches you the fundamentals of medium format film photography. You will:

- Learn about different medium format cameras to find one that suits you
- Learn the essentials of film photography
- Learn how to set exposure on your camera using a light meter
- Learn how to compose shots for square and rectangular formats
- Learn how to develop black and white negatives and understand what supplies to acquire
- Learn how to take corrective action if your negatives do not turn out correctly (it's always your fault!)
- Learn how to photograph negatives digitally in preparation for computer processing
- Learn how to convert your negatives to positives in Lightroom and process your images

Tools Used

Outside of the cameras, I use an iMac and Adobe Lightroom to process negatives. I sometimes use the NIK Collection Silver Efex Pro Lightroom

plugin. If you use Lightroom, download the NIK Collection. It's low cost and is one of the most useful Lightroom plugins available. You can certainly process your images without using the Silver Efex Pro plugin, but it gives you a good black and white baseline image to work with and tweak. Again, the NIK Collection is low cost and if you use Lightroom, I highly recommend it.

For photographing negatives, I use a Canon 24-70mm zoom lens with macro capability with a Canon 5D Mark III body. You need to use a macro lens if you photograph your negatives, otherwise you will need to use a scanner. The 5D Mark III is an expensive full frame sensor DSLR but you certainly don't need one. I've shot negatives using my old Canon 30D and they look great. A used Canon 30D body goes for a little over $100. Some kit lenses have macro capability, and they are inexpensive also.

If you decide to scan your negatives instead of photographing them, a decent negative scanner will run around $200. Macro lenses tend to be a bit on the expensive side. If you don't have one check out used lenses, and consider a kit lens. What's a kit lens? It's a lens that comes in a DSLR camera kit or package. These are much lower quality than the more expensive, stand alone lenses, but with do the trick if they are macro-capable.

Putting in the Time

Above all, film photography takes many, many hours of practice. It also takes discipline to slow down and record what you do, especially if you use a pinhole camera or experiment with different developers for your negatives. Also, if you want to learn the Zone System, it can take years to master. Completely mastering film photography is probably an unattainable goal, which is okay because you are always learning and improving. With each roll of film you become more aware and sensitized to the entire process. Your skills will also rapidly increase with practice.

After shooting and processing a few rolls, you'll be asking yourself, should I push the film for more contrast and grain? Where should I dodge and burn parts of the print? Should I meter for the light or the shadows? What area am I going to make middle gray? Where should I put my subject? Does the Rule of Thirds apply? It's all fun, exciting and is a lifelong endeavor.

There are two events in film photography that get your heart racing. The first is pulling your negatives from the developing reel to see how they turned out. Second, seeing a print emerge in a darkroom developing tray or an image coming to life when tone-reversed in Lightroom on a computer. There's always a sense of awe with it that never gets old.

Why Medium Format?

As I mentioned, most film photographers start with a 35mm camera. I did, and as I said after a couple of years I moved up to a medium format camera that uses 120 film. If you're coming from the DSLR world, a 35mm film camera has the same field of view as an expensive full frame sensor DSLR (Digital Single Lens Reflex) camera, such as a Canon 5D Mark III. To get the most out of our work with the techniques used in this book, we need a medium format camera. Why? Quite simply, the negatives are a lot larger, of better quality, and are more easily photographed or scanned. Is a larger negative better in the film world? Absolutely.

The figure below shows the approximate difference in size and format between 35mm and 120 film, which is medium format film. As you can see, the size is very different. The 120 film shown below is in square format, such as taken with a TLR (Twin Lens Reflex) camera.

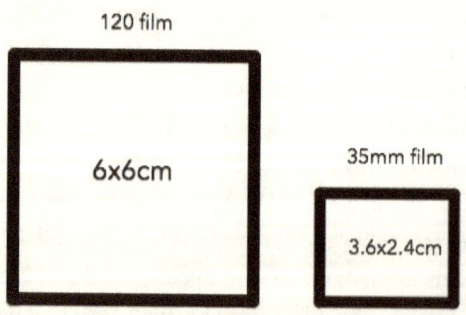

Here are a couple of negatives. As you can see, there is a lot more negative real estate to work with in medium format.

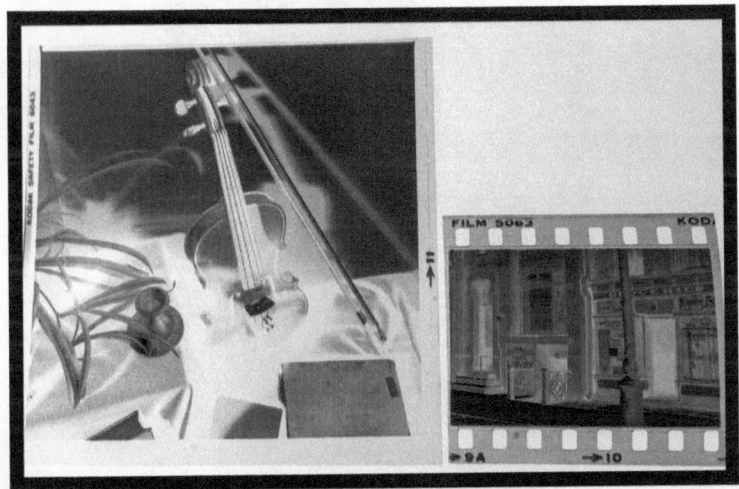

120 negative vs. 35mm negative

Medium Format Image Sizes

We are talking about negative image sizes here, not prints. There are generally two widely used medium format sizes, 6x6cm square and 6x4.5cm rectangular. The cameras used in this book utilize both formats. Even if you shoot with a 6x6cm square format camera, such as the Yashica Mat 124G used in this book, you can crop your prints anyway you want in post-processing. Several rectangular images in this book were initially shot in square format, like the photograph below.

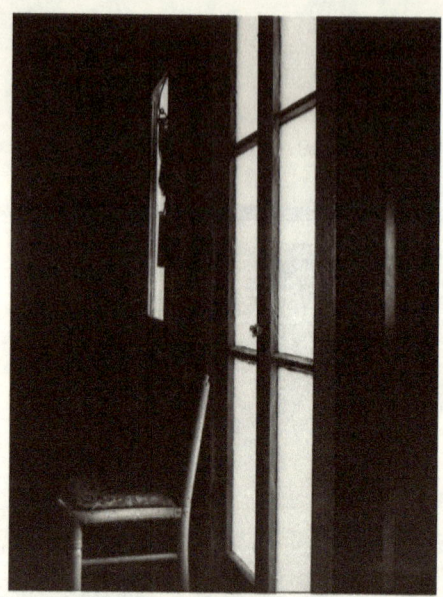
Yashica Mat 124G, TRI-X ISO 400

The shot of the window and chair was taken with the square format Yashica Mat 124G, even thought it's cropped horizontally. You don't need to be constrained by the format of the camera to shoot either in square of horizontal frames. It all depends on the photograph and how you want it perceived.

Medium Format Cameras

The medium format cameras used in this book are no longer manufactured, except for the Holga 120N that was discontinued but recently came back into production. This is actually good news. Thousands of medium format film cameras were manufactured over the years, and there are tons for sale on the Internet and are very affordable. Holgas are downright dirt cheap.

TLRs vs. SLRs

Basically, there are two types of medium format film cameras- TLRs and SLRs. TLR stands for Twin Lens Reflex and SLR stands for Single Lens Reflex. Both are used in this book. A TLR camera, such as the Yashica Mat 124G has two lenses. The one on the top is the viewing lens, the bottom is the taking lens.

You look down into the camera at the ground glass focusing screen through the viewing lens. When you snap a shot the taking lens opens, capturing the image. There is a slight offset from the taking lens from the viewing lens, but not much. For most images, it doesn't really matter, I've found. Here's what it's like looking down into a waist level focusing screen.

Yashica Mat 124G focusing screen

Looks pretty cool, doesn't it?

With an SLR, such as the Mamiya 645E, you look through the viewfinder, seeing your subject through the one and only taking lens. What you see in the viewfinder is what you get on the negative. SLRs are easier to work with when you start shooting in medium format.

It's a little more difficult working with a TLR, but you will quickly learn to love it. TLRs have waist level viewfinders. You hold the camera at your waist and look down into the focusing screen. It takes a little getting used to. To make things more disorienting, the image you see in the focusing screen is backwards. On the up side, it only takes a roll of film or two to get used to a TLR. I love composing on a square, waist level focusing screen and have got some of my best shots with my TLR. Much more expensive medium format film cameras, such as Hasselblads, use waist level viewfinders.

Yashica Mat 124G

I started out in medium format photography with a Yashica Mat 124G twin lens reflex that shoots 120 film. The 124G provides a 6x6cm (2.25x2.25in) square format negative. Compared to a 35mm negative, the 120 negative is enormous, as was shown previously. I put the camera away around thirty years ago and pulled it out of a closet and cleaned it up when I was bitten by the film bug again. At this writing, a used Yashica Mat 124G runs anywhere from $200 to $400, give or take a little. They seem to be inching up in price since film photography's resurgence. The only comparable twin lens

reflex camera that I know of is a Rolleflex, which may be in the thousand dollar range on up for a decent used one, and that may be without a lens. My Yashica Mat 124G is as functional and reliable as the day I got it. There are plenty on the market and I really recommend grabbing one of these cameras if you can.

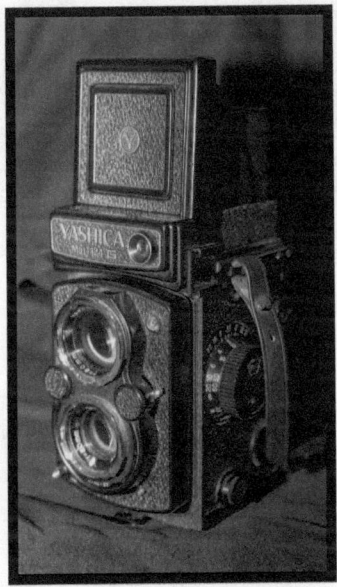

Yashica Mat 124G

The cover shot of the violin was taken with the Yashica Mat 124G. The 124G sports a Yashinon 80mm f/3.5 lens which is exceptionally sharp. The exposure range is from f/3.5 to f/32. The shutter speeds ranges from B (bulb) to 1/500 sec. The films speed range is from ISO 25 to 400. The camera housing is metal, is heavy and a bit bulky to carry around, but it's as solid as any camera out there and is built to last.

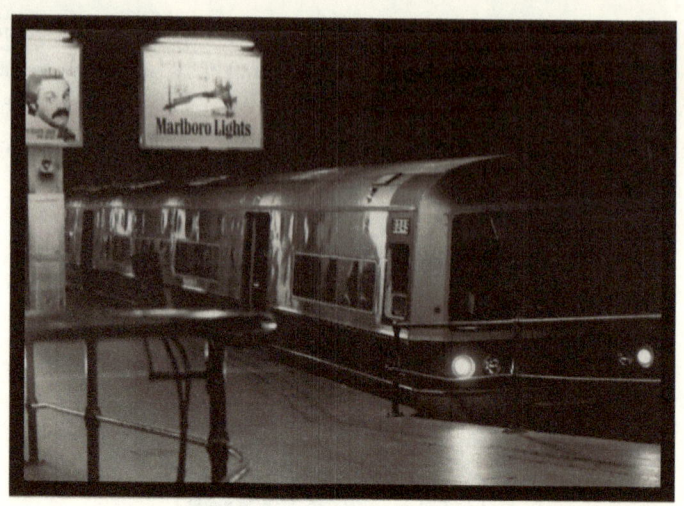

Yashica Mat 124G, TRI-X ISO 400

Mamiya 645E

I also have a Mamiya 645E medium format camera. The 645E is a fairly modern medium format SLR, being introduced in 2000. The 645 designation stands for 6x4.5cm format, which is rectangular. This is my go to medium format camera. It's an SLR (Single Lens Reflex) camera and the shooting experience is vastly different from the Yashica. Instead of a waist-level finder, you look through the viewfinder and the taking lens similar to a DSLR.

The 645E is a baseline model Mamiya, and was discontinued in 2007. It's a simple, well built camera, although the body on the 645E is plastic, not metal. Not that this detracts from the camera- it feels rock solid. On the camera body, the shutter speed dial is on the left and there's a wheel for exposure compensation on the side of the prism, which is very handy for bracketing exposures. The ISO setting wheel is in the rear below the viewfinder. It only takes a few minutes to get the feel of this camera.

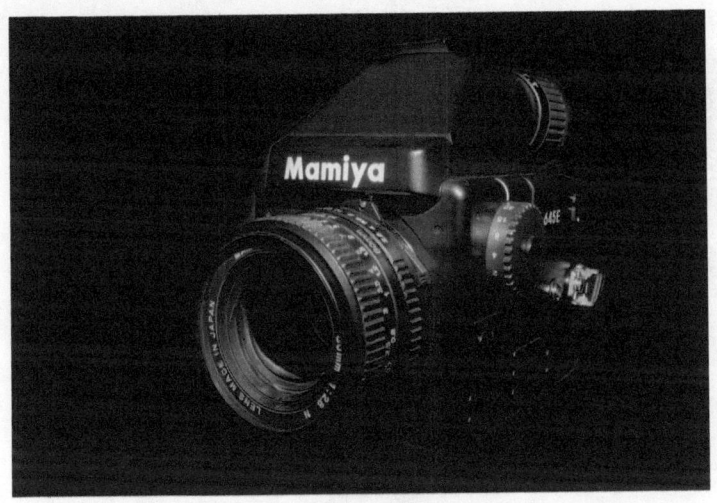

Mamiya 645E

Film is loaded in the back via an insert, where more advanced medium format cameras have "backs" that attach to the rear of the camera. Having more than one back is handy, since you can carry a variety of film, such as transparency, color film or different speed black and white and can change film backs from one to another at any time. Not so with the 645E. This is not a big deal, since you can carry extra inserts. I have an extra insert for my 645E that is housed in a light-proof box, so I preload that with film before I go shooting. The disadvantage is that you cannot change inserts until a roll of film is completely exposed.

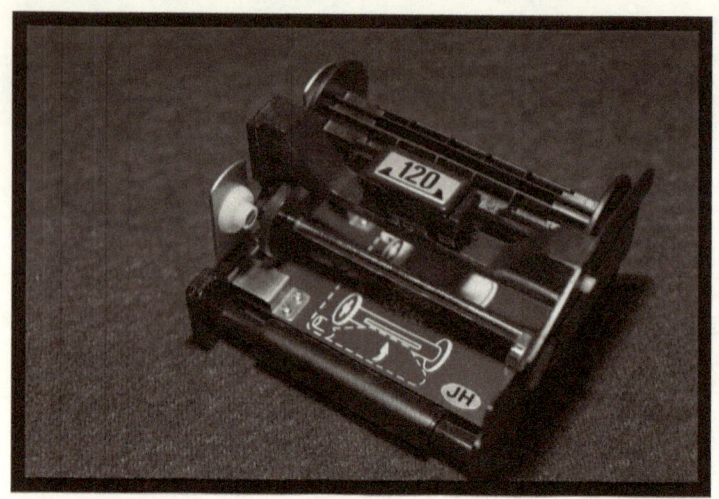

Mamyia 645E Film Insert

My Mamiya 645E came with a 80mm f/2.8 lens, which is pretty much standard. It's a good, sharp lens that Mamiya is renowned for. Additional lenses for the 645E are very reasonable, so it won't break the bank getting a wide angle or telephoto lens.

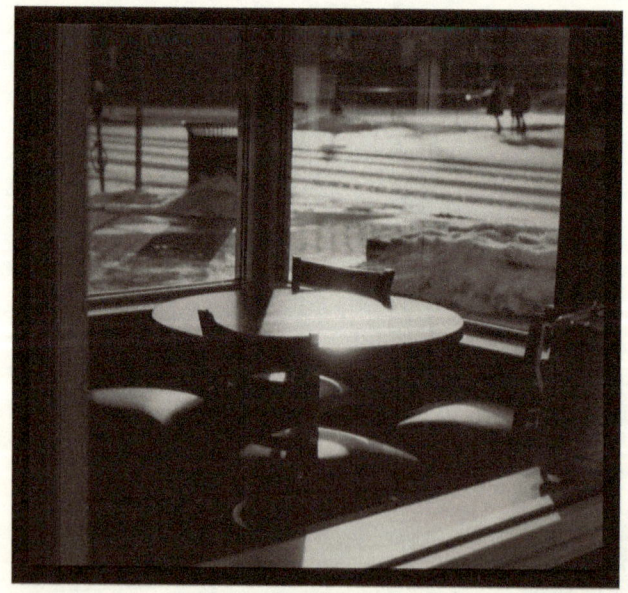

Mamiya 645E Ilford FP4

The camera controls are all within easy reach and are intuitive. Except for learning how to load film into an insert, you only need to glance at the manual. The shutter speed dial is on the left side and is easy to use and read. The ISO setting wheel is on the upper right of the case and there's an exposure compensation dial on the right side of the prism housing. There are two levers, one for multiple exposures and another for mirror lock up. Also, there's a circular diopter adjustment on the viewfinder, which allows you to correctly focus depending on your vision. This is a real benefit for me. Here's a hint. When you find the diopter setting that's best for you, lock it into place with a small piece of transparent tape. Otherwise, it tends to move around when you handle the camera.

Mamiya 645E Ilford FP4

The 645E is an entry level medium format SLR camera in the Mamiya line, but is perfectly adequate for professional use. There are much more expensive cameras, such as Hasselblads, and better Mamiya cameras in the 645 series, but I'm perfectly happy with the 645E. It's easy to use, the dials are all in the right places and it's reliable. You can pick up a Mamiya 645E with an 80mm f/2.8 lens for around $300 to $500. It is well worth the money.

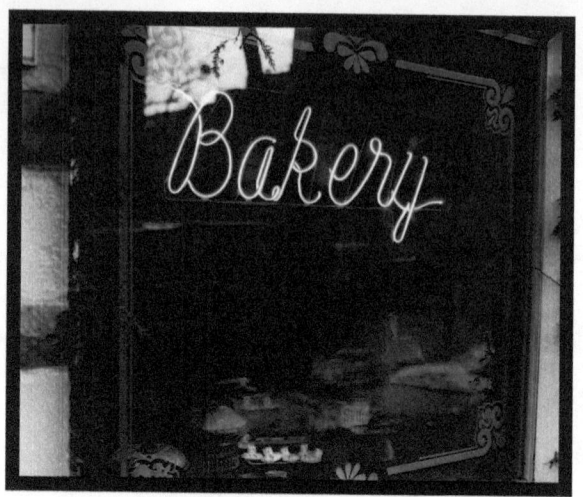
Mamiya 645E Ilford FP4

Unlike the Yashica Mat 124G, the image size on the Mamiya 645 negative is a rectangular 6x4.5cm. If you are lucky enough to acquire both types of cameras, you have the best of both worlds when producing medium format images.

Holga: Back from the Dead

On the other end of the spectrum from a quality 120 film TLR or SLR is a cheap, plastic Holga. They are classed as "toy" cameras, but don't let this put you off. Holgas have a rabid world-wide following. A bare bones Holga 120N runs around $40 new. I have three Holgas, a 120N and two pinhole versions. I love and hate these cameras. They are radically cheap, so much so that if you don't tape the back cover to the body it will fall off. Guaranteed. It's happened to me several times with film in the camera. You can see the tape on mine on the image below. The lenses are crude plastic, the film advance is manual and primitive, exposure is coarse and the bodies leak light like crazy. But guess what? The images they produce are stunning and unique.

Working with a Holga is first and foremost an exercise in self discipline and restraint, since I have to admit there are times when I would love to put my Holgas underneath my car tires and flatten them. That being said, when you develop your negatives and prints you will be shocked at how cool they look.

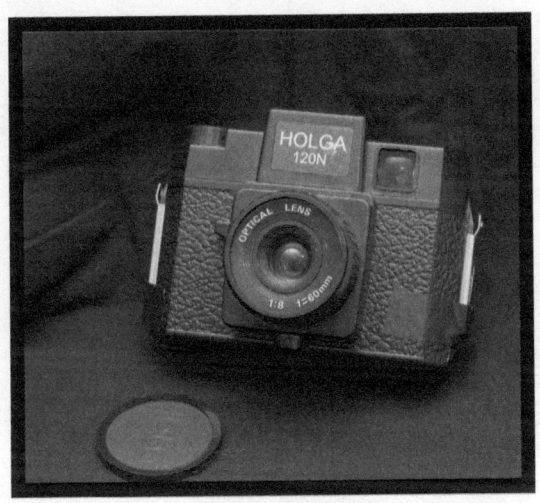

Holga 120N

The Holga takes 120 film only. The lens focal length is fixed at 60mm. Focus is adjustable from 0.9m to infinity by adjusting the lens in four different crude positions. The shutter speed is fixed at 1/100sec and the settable aperture values are f/8 and f/11, which is controlled by a simple switch above the lens. The viewfinder is plastic, as is the lens. It weighs next to nothing so it's easy to carry around. As you can see, mine is starting to show some wear and tear.

Holgas are so cheaply made and quirky, there are no two alike. That's also what also makes them endearing. Your Holga, even thought it may be the same model, behaves differently than mine. My Holga 120N is very unpredictable, leaks light like crazy and yours will be also. Just accept it and keep shooting. Your Holga will produce images like no other camera will.

Holga 120N **TRI-X ISO 400**

Here's what's on a Holga box:

"A Holga Camera is a study in plastic imperfection, and to use it is an exercise in breaking free from dependence on technology, precision, and uber-sharpness. The slight softness of the images, uncontrollable vignetting and peculiar light leaks create a partnership between you and your Holga. These "flaws", accompanied by your creative choices, result in a quasi-serendipitous form of art. A Holga stretches our visual perception. Using a Holga adds another facet to the way we see the world. We notice more things, and thus we examine and evaluate their status. A Holga is an educator teaching us a new visual vocabulary with which to describe the world. A Holga is a rule breaker. To use a Holga is to utterly change the terms of reference most people use to interpret photography."

A lot of hyperbole and it's a big time stretch for a toy camera, but there is some truth in it. Shooting with a Holga 120N, despite its quirks, is the fastest, cheapest pathway into medium format photography.

Holga Shooting Caveats

There are two important things to watch for when you shoot with a Holga:
1) Make sure the lens cap is off.
2) Make sure you advance the film after each exposure.

I can't stress this enough. If I'm not shooting with a Holga for awhile, I will always double expose at least one shot by forgetting to advance the film. Remember, *everything* on a Holga is manual. On a TLR or SLR, after you take an exposure the shutter release is inactive or locked until you advance the

film. Not so with a Holga. You have to carefully advance the film yourself.

Holga 120N, TRI-X ISO 400

Holgas have view finders separate from the lens, so it's very easy to leave the lens cap on while shooting. For example, if you're on a field shoot at Niagara Falls, live hundreds of miles away, and only have one day to shoot, leaving the lens cap on is a complete disaster. Am I speaking from experience? I'd rather not say...
Remember, Holgas have cheap plastic lenses, so don't worry too much about scratching or abusing it. Another way to remember is to tape a reminder on the back cover, like I do.

Holga 120N back
The back cover reminder can save your shoot.

Double Exposures

There's a positive side effect to not winding the film after you take an exposure. You can effortlessly take double exposures. Here's an example taken with a Holga Pinhole.

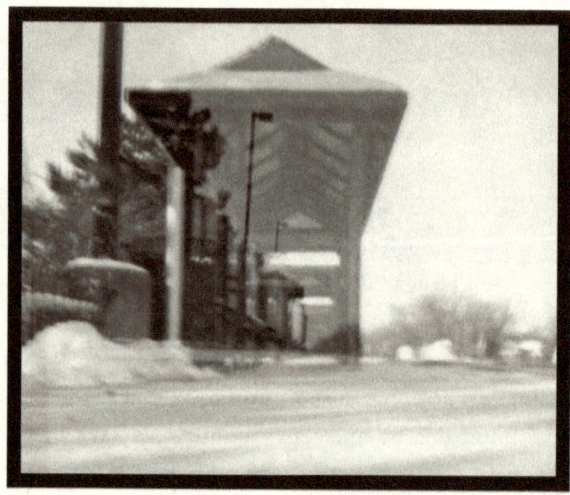

Train Station, Holga Pinhole

There aren't a whole lot of film-based double exposure prints nowadays. At least I haven't seen many. Doing cool double exposures is an art in and of itself, and a lot of talented photographers are into it. You can easily do double exposures on any Holga, so if that's your thing, go for it.

Holga Pinhole

If using a regular Holga is an exercise in patience, try a Holga Pinhole. Here's mine:

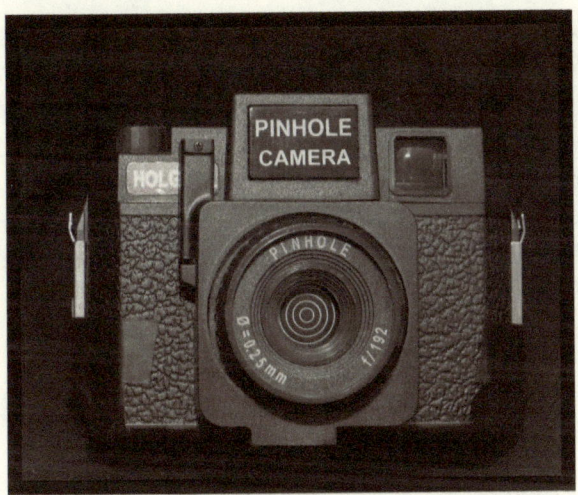
Holga Pinhole

Pinhole cameras do not have a lens. You manually hold open the shutter for a number of seconds, depending on the lighting conditions. There's a crude exposure guideline on the back, but using these are mostly guesswork. If you want to do it right keep a notebook for every exposure when you start out using s pinhole camera for a couple of rolls to get the feel of your particular camera, because every Holga is different. There's a whole section dedicated to using the Holga pinhole camera. Like the Holga 120N, the Holga Pinhole takes 120 film.

Bad News, Good News

The Holga factory shut down on November 25, 2015. From what was announced at the time the tooling was completely destroyed, so the bottom line was Holga production had stopped forever. A factory spokesman in China stated, "All Holga tooling has already been thrown away and there is nothing available for sale."

I wrote the next two paragraphs on a blog post back then, not knowing that Holga was making a comeback:

The remaining supply of Holgas are all that are left, and those seem to be going fast. Rumor has it the price of Holgas will go through the roof but that remains to be seen. I plan on buying another 120N and Pinhole just to have as spares.

There are many, many Holga purists around the world so this is truly disappointing news. Holga cameras have been around for 33 years, so it's sad to see them go. In a way it

almost makes 120 film format more hip shooting with a Holga, now that it's a thing of the past. If you have a Holga you now own a vintage camera. If you plan on buying one, do it soon before they disappear. The bottom line is hold on to your Holga- it is a true treasure.

That was then, this is now, and there is good news. It turns out the Holga tooling was not destroyed, and a factory in China is making the Holga 120N. It sells for $40 and is available from most on-line camera stores. I suggest buying one before they go away again. You never know!

Pinhole Cameras

There is no simpler method of shooting photographs than with a pinhole camera. The main pinhole used in this book is of course, the Holga. Unlike the 120N, Holga Pinhole cameras have truly been discontinued, so they might be a little hard to come by these days and the price is going nowhere but up. If you see a deal on one, grab it.

Holga Pinhole

We will also take a look at the Zero Image 2000 pinhole camera, which is much higher quality. To me, photographs taken with pinhole cameras appear ethereal, impressionistic and timeless. There's that word again- *timeless*. That just goes along with pinhole photography. There's a softness and otherworldly feel to pinhole photography that's hard to replicate with other cameras. Earlier I mentioned that one of the thrills of film photography is pulling the negatives off the developing reel for the first time. The thrill is amplified with pinhole photography. Exposure is mostly guesswork, and when the negatives come out well, they really come out.

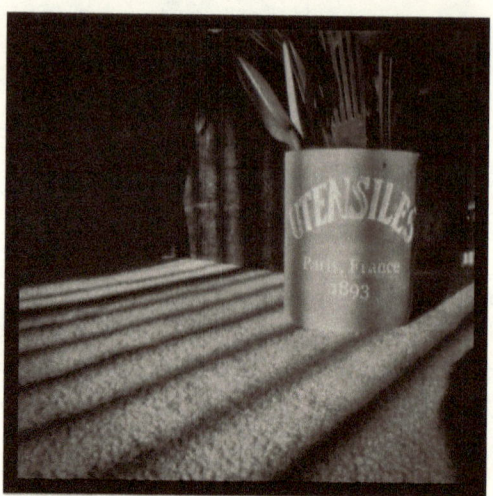
4 second exposure, TRI-X at ISO 400

This extreme simplicity comes at a cost- you have no real reference point for correct exposure. Instead of exposing film through a lens, a pinhole lets in light. There is nothing to focus on and there is no aperture setting to control depth of field, which is considered infinite on pinhole cameras. The pinhole is manually exposed to light, then closed.

A lot, if not most pinhole photographers use a cable release when they shoot. This is optional for the Holga and the base mode Zero Image pinhole. It's all a question of stability. Pinhole exposures can take a while, from seconds to many minutes. Using a cable release reduces camera shake and finger fatigue for long exposures.

If you're using a tripod and hold the camera down when you shoot, the image comes out stable, if you're careful. The Holga cable release is very flimsy and will break. I was constantly fixing mine with duct tape, and it finally completely fell apart on a shoot. I bought a good quality cable release and haven't looked back. If you use a tiny tripod on occasion like I do, using the cable release makes the Holga wobble unless you really hold it down.

I like my pinhole images to be from the ground up so a lot of the time I'll use a mini-tripod. Of course you can use any tripod at any elevation you like. The cable release assembly for the Holga pinhole is a mechanical contraption that fits over the lens. You can see it on the photo of the Holga pinhole below. Although not essential, I always use a cable release with a pinhole, since, as I mentioned, the pinhole covering needs to be open multiple

seconds.

Here's my basic Holga Pinhole setup. Notice the black tape holding the clips on, just like on the Holga 120N. It's gotten worse so now I use duct tape.

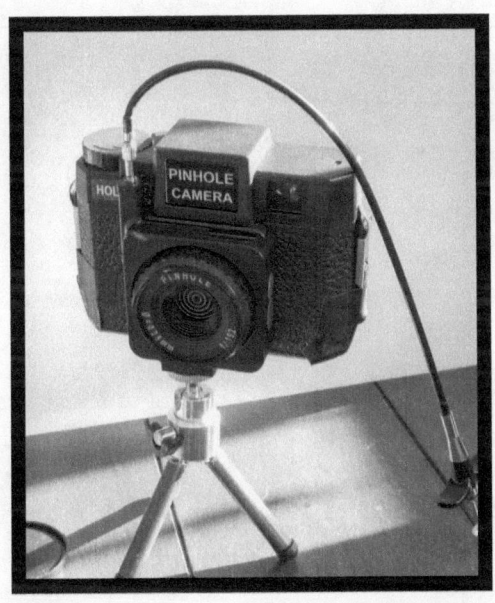

A pinhole camera is simple, but pinhole photography is not, especially when using film. With a digital camera a histogram is usually available to check for proper exposure. Not so for film. There are rough guidelines for exposure, such as 1- 4 seconds on a bright day, but these are not very accurate. Some pinhole exposures take many minutes. A lot of experimentation and frustration is in store, but the outcomes are great- fantastic images that no one else could produce except you and your pinhole.

Zero Image 2000

Alternative, higher quality medium format pinhole cameras are available. One such camera is a Zero Image 2000. Mine is shown below.

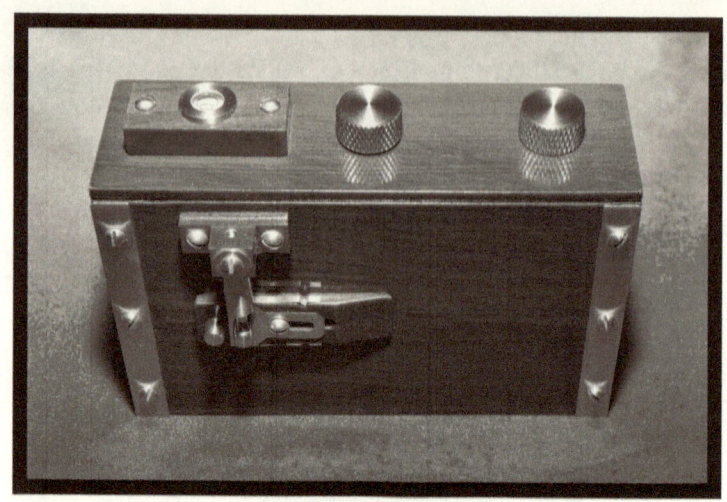

Zero Image 2000

This is a high quality teak and brass camera that isn't afraid of rain, which is an asset for any camera. The version shown above is the deluxe model, which runs around $235. The baseline mode does not have the cable release mechanism or the bubble level. I could live without the bubble level, but not the cable release.

Here's a rear view:

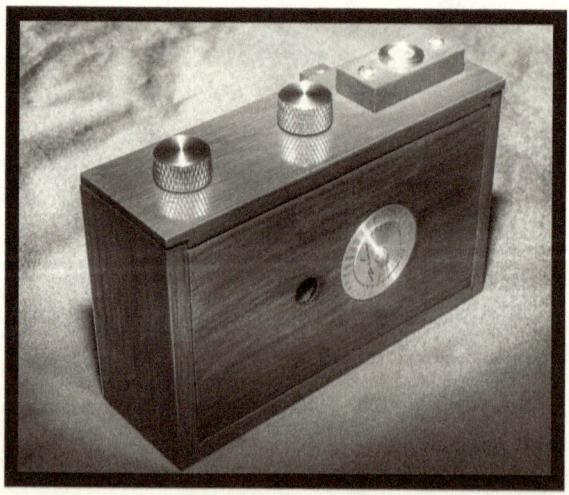

Zero Image 2000

The dial on the back allows you to take a light meter reading, rotate the dial to the focal length of the 2000 pinhole camera, and get the proper exposure time. The focal length of a pinhole camera is fixed and enormous. The focal length of the Zero Image 2000 is f/138.

Here's a still life of some geometric forms taken with the Zero Image 2000:

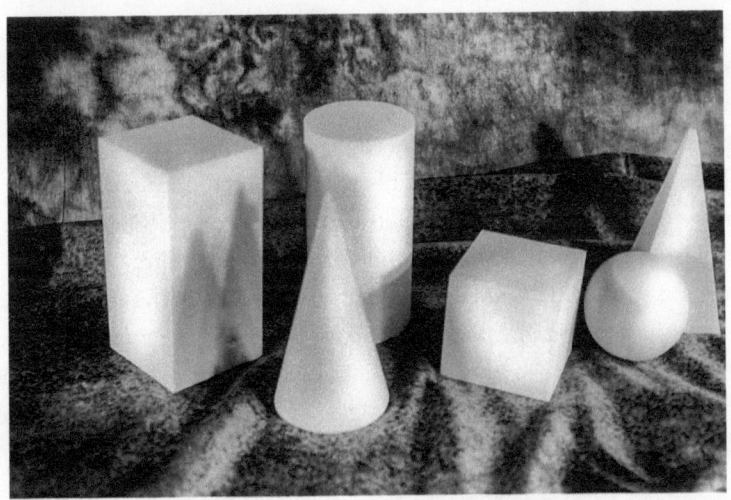

3 second exposure, Zero Image 2000 TRI-X ISO 400

Unlike the Holga, the Zero Image 2000 is very sturdy and if taken care of, should last a lifetime.

Keep an Optional Notebook

If you really want to determine your pinhole camera characteristics quickly, be scientific about it for a couple of rolls of film. Keeping a notebook is clearly optional, and it takes a lot of discipline to maintain one but it will help in the beginning.

I am not religious about maintaining notebooks, although looking back, I wish I was more disciplined making entries. I've found a lot of notes from really old shoots that are interesting and informative, even now. Reading the notes I remember a lot of the shoots that I had forgotten about. Aside from being functional, notebooks are entertaining when you look at them a few years down the road. They record your lifelong photographic journey.

For each frame you shoot, record the film type and other exposure information in your notebook, as detailed below.

Getting Your Pinhole Dialed In

Here are the steps that I used to get my Holga Pinhole up and running: Start with using the camera manufacturer guidelines. For the Holga, the "Fine Weather" setting is 1.5 to 3 seconds. For "Overcast" it's 4-6 seconds. For "Morning or Dusk", the golden hours, the exposure time is 7 seconds and upwards.

Shoot your first roll using these guidelines and record the exposure time for each frame in your notebook. I take my light meter and get a reading first at the ISO of the film you are using, and record that also. I do this to get a relative feel of what the ambient light relationship is versus the Holga guidelines for the film I'm using. This sounds like a lot of work, and it is, but this puts you on the fast track of getting the feel for pinhole exposure times. You will probably only need to do this for two rolls of film.

Develop your film and make contact prints or shoot the negatives and pull them into Lightroom. If the exposure is way off, incrementally adjust the exposure time up or down on the next roll of film. The whole process is iterative, and remember, no two Holgas or even Zero Image pinholes are alike.

3 second exposure, Holga pinhole TRI-X ISO 400

There are many more good pinhole cameras on the market, and I intend on checking them out in the future and take it up more seriously. I tend to like simple things and a pinhole camera, or "camera obscura" as they are called, is as simple as you can get.

4 second exposure, Holga pinhole TRI-X at ISO 400

Pinhole photography isn't for everybody and some photographers do not like the images they produce. If you get hooked on pinhole photography (which is very easy to do), be prepared to spend a lot of time with it and expect to fail a lot. With some practice, though, be prepared to produce remarkable art.

Pinholes and Light Leaks

This last comment regarding the Holga and Zero Image pinholes is important. Do not leave your film in your Holga or Zero Image for an extended period of time. Why? Remember, Holgas really leak light. Zero Image pinholes aren't as bad, but they still will leak. Light will creep over your film inside the camera body, clouding and streaking your negatives. Shoot a roll then get it out of the camera and store it until you're ready to develop a batch of negatives.

Vintage Cameras

If you really want to go retro, pick up a vintage medium format camera. I found this German Agfa Prontor II at an antique shop and bought it for

$60. It appears to be in good working condition, although I haven't shot with it yet. A lot of photographers are into vintage medium format cameras, like the Agfa below. Just scout around antique shops and garage sales and you might really come across a jewel.

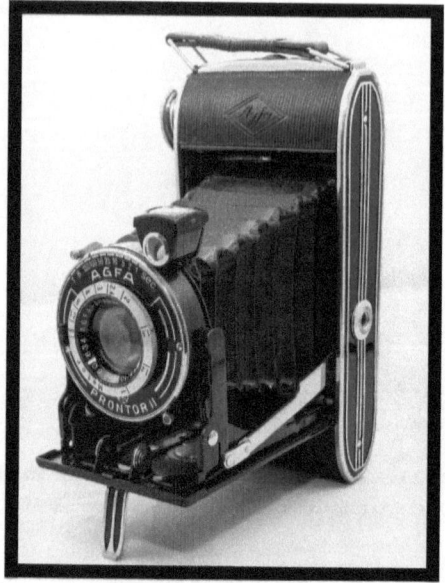

Agfa Prontor II

What's Right For You

You have to really think about what medium format camera is right for you. The easiest and least expensive way is to start with a Holga 120N. For forty dollars you can't really go wrong and at least you'll be working with film. The path of least resistance is to buy a Holga, shoot your film and have it processed for you. There are camera stores and labs that provide film developing services and are pretty reasonable. They can even make prints for you, but we will be using digital methods for that. Consider this option as just putting a toe in the water of medium format photography. You may want to do this before you dive in head first.

If you have played with your Holga for awhile, you may want to stay with it and try a Holga Pinhole, or even a Zero Image. Many people do, and they are truly creative artists, developing their own negatives and producing beautiful images with their unique cameras. I admire and respect these artists.

If you want to move onward and upward, the next step is to get your hands on a SLR such as a Mamiya 645E or a TLR such a Yashica Mat 124G. A SLR will be a lot easier to initially use, since viewing is through the lens. If you really want to make composing a shot a truly different experience, try a TLR.

Yashica MAT 124G Tri-X at ISO 400

I want to stress that TLRs with waist level finders are in no way inferior to SLRs. The classic, top of the line Hasselblads utilize waist level finders. It's all a matter of personal preference and how much you want to initially take on in the learning process. I'm not going to make a specific recommendation since I use them both, but I will say I started medium format photography with a TLR and still love it to this day.

Mamiya 645E Tri-X at ISO 400

As of this writing, there seem to be a lot of reasonable Mamiyas and Yashicas around. For TLRs, Rolleflex cameras are available but are very expensive. For SLRs, I've seen more Mamiyas for sale than other brands. There are a lot of great SLR cameras out there, such as models made by Pentax, Bronica, Contax and Fuji to name a few. Bargain hunt and I bet you'll find a great camera and lens for a reasonable price.

Yashica MAT 124G Tri-X at ISO 400

Take Your Time

Take your time selecting a medium format camera. If this art form really takes you, chances are you'll invest in a TLR or SLR. If you're mildly interested and curious, start with a Holga, have a lab or camera store develop your negatives and go from there. Hold your initial frustration in check if things don't start so well. Film photography takes time and practice.

Essentials of Film Photography

Let's assume you now have access to a medium format camera and you're ready to shoot. So how do you use it? There are three foundational principles to understanding film exposure- aperture, shutter speed and ISO (film speed). You may already be an advanced DSLR user shooting in Manual, Aperture or Shutter priority modes. This section will be old hat to you, but please keep reading, since the ISO is relatively fixed when you shoot with film and the only real way to change it is in the negative development process.

Exposure

Exposure determines the amount and duration of light allowed to fall on film. Exposure is adjustable via aperture and shutter speed settings. Unlike a digital camera, ISO is fixed by the film you use. I used black and white film exclusively, specifically TRI-X (ISO 400) and Ilford FP4 (ISO 125). The only way to effectively change ISO is to "push process" the negatives while developing. TRI-X is very amenable to push processing, I've found. There will be more on push processing in the Developing Negatives section.

Aperture

Aperture controls **how much** light a lens allows to fall on the film. Aperture is measured in f-stops. The lower the f-stop, the more light enters the lens. Lenses with low f-stops like f/1.2 are expensive compared to slower lenses. The rule of thumb is the lower the f-stop the more expensive the lens. Interestingly, the one and only f-stop for the Holga Pinhole is f/192.

For this book, interchangeable lenses are mostly a moot point since the cameras used here all have fixed lenses except for the Mamiya. The Yashica Mat 124G has an 80mm fixed lens and the Holga has a 60mm. I have one lens for the Mamiya, and that's a standard f/2.8 80mm lens. As we know, the

pinhole camera doesn't have a lens, just a little hole.

An 80mm lens on a medium format camera roughly translates to a 50mm on a full frame DSLR. A 50mm lens on a DSLR or a 35mm film camera is the standard, go to lens for many photographers.

So why the term "f-stop"? The f stands for focal ratio. Each f-stop allows in twice as much (or twice as little) light as the f-stop next to it. F-stops generally scale from 1, 2, 4, 8, 16 and so on. F-stops at first glance seem backwards. f/11 is a larger number than f/2.0, so you would think f/11 lets more light through the lens. The opposite is true. The greater the f-stop value, the less light is allowed through the lens.

Depth of Field

Depth of field is directly linked to aperture. Depth of field, or DOF, is what is in focus in front of and behind a subject. DOF is primarily controlled by aperture setting or f-stop. A lower f-stop number, such as f/1.8 will have a shallow DOF, meaning a smaller area will be in focus. If you want to increase the depth of field, you need to increase the f-stop, which means you let less light in through the lens.

To keep exposure the same when you increase an f-stop you need to decrease the shutter speed. For example, if you are shooting at f/8 at 1/250 and want to increase the depth of field, you could increase the f-stop to f/11 and decrease the shutter speed to 1/125. This will keep the exposure the same. On a digital camera you could simply increase the ISO value, but as we know that's out of the picture with film cameras.

Film cameras have depth of field scales on either the lenses or bodies. I really do not use them much, if at all. Just understand that with a open f-stop, such as f/2.8 the depth of field around your subject will be very shallow. At f/32 almost everything will be in focus.

Shutter Speed

If aperture controls how much light hits film, shutter speed controls how **long light** sits on the film. The shutter speed works like an f-stop. It either doubles or halves the amount of light hitting the film by keeping the film exposed to light for a longer or shorter period of time via the camera's shutter. Shutter speed values are expressed in reciprocal seconds. For example, a shutter speed of 1/15 means that the film will be exposed to light for 0.066 seconds.

Why is it when you change film from say ISO 400 to ISO 100 the shutter

speed and f-stop values are different? ISD 400 film is more sensitive to light than ISO 100 film.

You will sometime hear the term "reciprocity". It really means that changing one exposure setting changes another. ISO, aperture and shutter speed are all related. It makes sense that if you have a properly metered exposure and the aperture is adjusted to a different f-stop to let in twice the amount of light, the shutter speed must be increased to allow half as much light as previously allowed to enter. That keeps the exposure equal.

With a Holga, all you need to bear in mind are the light conditions you will be shooting in since you have very little control over exposure. I use TRI-X for normal daylight shooting and develop the negatives at the default ISO of 400. If I'm shooting in the evening or at night, I'll still use TRI-X and I'll push process the negatives to ISO 800 or 1600. All this really means is that you keep the negatives in the developing solution for a longer time and setting the ISO differently on your camera, if it allows it. We will talk more about this in the Developing Negatives section.

How To Use Your Camera

In these sections we'll go over the basics of using a medium format camera, whether it's a TLR, SLR, or Holga. They are all pretty easy to set up and use, but don't have a lot of features and settings photographers take for granted on a digital camera. There are a few mechanical hoops to jump through, except for a Holga 120N. Just point, shoot and wind a Holga.

Loading Film

Loading film into the cameras isn't complicated, but they are all a little different and contain a few steps each. The main thing to avoid is exposing film to light while you're loading it into your camera. If possible, load your film in a dimly lit room.

Loading a TLR

We'll start with loading a TLR, such as the Yashica Mat 124G. Open the back, switch the spool from the bottom holder to the top, then insert the film. Insert the paper into the top spool and start winding until the arrow on the film and the film start indicator line up. On the Yashica Mat 124G there are two triangles on the left side pointing toward the start mark of the film. One is green for 120 film, the other for 220 film. The difference between the two is there are 24 exposures on 220 film instead of 12. 220 film is no longer made to my knowledge. Make sure the start mark is stopped at the green triangle, otherwise your exposures will be messed up. Also, there's a pressure plate on the back of the cover that is adjustable to two positions, 12 and 24 exposures. Make sure it is set to 12 exposures before you shut the back.

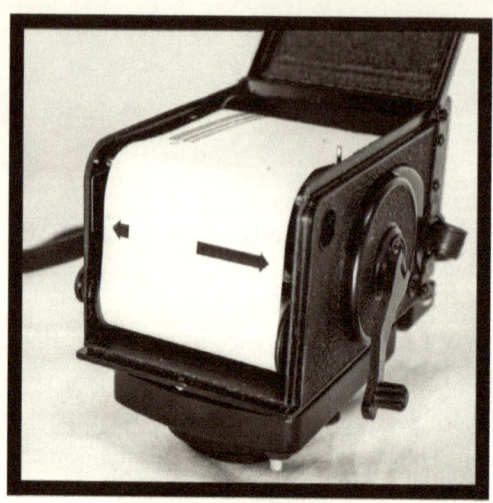
Yashica Mat 124G

Close the back and wind until the number 1 appears in the exposure window, which is on the right side toward the top of the camera. The winder should stop. When it does, reverse the winder and put the end in the detent. With each shot, advance the winder until it stops, reverse it and put it into the detent.

Always lock the shutter release. Just rotate the release lock to the red L position. That way you will not inadvertently take an exposure and waste a shot.

Loading a SLR

Most SLRS come with a back or an insert. Backs and inserts are separate from the camera. Backs are handy since they can be switched mid-shoot. Let's say you've exposed five black and white shots, and want to switch to color transparencies, you can by switching backs. Most photographers carry several backs with them on a shoot. Here, we're dealing with inserts.

Loading the film isn't really difficult and the instructions for loading film into medium format cameras are widely available on the web. Here's a shot of the Mamiya 645E insert. The trick to loading film is that the paper cover side is down and the printed paper backing is up, so the film side faces the interior of the camera. Take the spool, shown in the upper position and put it in the lower slot. The side holder arms swing down for easy film insertion. Wrap the film around and insert it into the take up spool like shown in the lower part of the insert. By hand, advance the film to the starting line. Keep some

tension on the film so it isn't loose. Line up the film's starting mark with the insert's starting mark. That's all there is to it.

Mamiya 645E Film Insert

With the Mamiya 645E, insert the back into the rear of the camera. You can feel it snap into place. Shut the rear door. An S will appear in the exposure number window. Like a TLR, advance the winder until the number 1 appears in the window. It's always good to take at least one extra insert with you loaded with film and ready to go. Otherwise, you'll be unloading and loading film at your shoot location which takes extra time. That translates to less shooting time.
Since the Mamiya 645E shoots images in 6x4.5cm, you will get 16 exposures instead of 12.

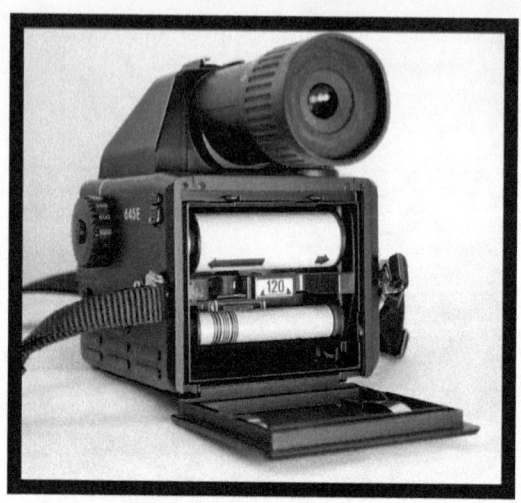

Mamiya 645E Film Insert

After you've loaded your film, lock the shutter release. Similar to the Yashica, rotate the lock ring to the red dot.

Loading a Holga

As you might have guessed, loading film in a Holga is as simple as it gets. Just switch the film take up spool to the right, load the film on the left, attach the film to the spool and wind. Once it gets going, put the back on and wind until the number 1 appears in the red window. You're now ready to shoot.

There's a window on the back that's selectable for 12 or 16 exposures. Holgas come with inserts, or masks, that fit inside the camera body. Without the insert installed, the Holga shoots 12 6x6cm square format exposures, like the Yashica. With the insert installed, it shoots 16 6x4.5cm rectangular exposures, like the Mamiya. Flip the plastic indicator to 12 or 16, whichever you are shooting. If you want an image size of 6x4.5cm like the Mamiya, do not forget to install the insert inside the camera body.

Personally, I always shoot in square format 12 exposure mode with my Holgas. That's just my preference, and yours may be different.

Unloading Film

Unloading film couldn't be simpler. Just open the back and take it out. Once the film is out of the camera, make sure the paper is tight on the roll to prevent any light leaks. There's a loose adhesive strip of paper on the film roll. Lick one side of it and wrap it around the film tightly. The film is now

ready to be stored in a refrigerator or processed. How long does film last? I've read stories where fifty year old film stored in a refrigerator developed clear, clean negatives. Why store film in a refrigerator? It helps to keep it fresh and extends shelf life. I have a spot reserved in my fridge for film.

Film gets more brittle over time, so try and develop your negatives promptly. On each box of film is an expiration date. Try and shoot the film well before that comes to pass. I found some 120 rolls of film that were sitting around for a few years and had a difficult time getting the film on to the development spool since it was so curled and brittle.

Getting Your Camera Ready

There are some important things to do before you grab your camera and go shooting. I always start from a baseline shutter speed and exposure. I set the shutter speed to 1/125 and the aperture to f/5.6. This is a good middle ground setting. I make sure the ISO is set to the film I'm using. I also make sure my light meter is set to the same ISO as the camera and the film.

Before I load a roll of film I clean the lens and squirt some air into the interior of the camera holding it upside down.

Also, and most critically, make sure film is loaded in your camera before you head out. Make sure you have an extra roll or two in your camera bag. This sounds silly but it happens, especially if your coming from the digital photography world. It's like forgetting a memory card for your DSLR.

ISO

It's worth talking about ISO a bit. ISO stands for International Standards Organization. Film speed is rated via ISO (it used to be called ASA). The higher the ISO rating, the more sensitive the film is to light. High ISO rated film is called "fast" film, and requires less exposure time to capture an image. Low ISO rated film is called "slow" film. It is less sensitive to light, so it needs longer exposure times. So which one to use? It depends on how and what you shoot and is a matter of personal preference.

If you're primarily into detailed landscape photography, still life or portraits, then definitely go with a lower ISO rated film, around the ISO 100-125 range. If you're into street and more grainy action oriented or low light photography, go with film that's rated at ISO 400. I've been using TRI-X at ISO 400 and Ilford FP4 at ISO 125 and bounce between the two.

Light Metering

In order to get accurate exposures, you need a light meter. Most cameras have built-in light meters, and a large population of digital photographers depend on internal light meters. I do in most cases when shooting digital unless I'm doing studio work. It's not the same with medium format film photography. I rarely use a film camera's internal meter. I almost always use a hand held light meter, if possible.

You can buy a used light meter for little money, and they're very effective. I've had the light meter below, a Sekonic L-158, for probably thirty years, and I sill trust it and use it. It doesn't need a battery and is so old the film speed is designated as ASA instead of ISO. At the time of this writing a Sekonic L-158 goes for around thirty dollars and is well worth the money.

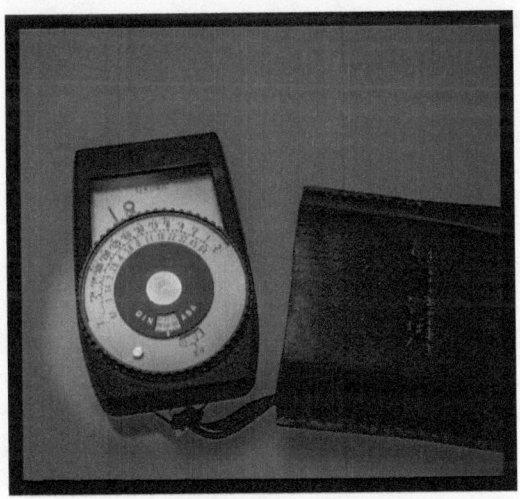

Sekonic L-158

Actual Shooting

Out in the field or in the studio, you need to measure the light correctly to set the exposure. If you're using a low-cost Holga, there are no discrete

shutter speed or aperture settings, other than a few click-stops on the lens. A light meter is useless. If you're using a more capable camera, such as a TLR or SLR, then you can use the camera's internal light meter (if it has one) to adjust aperture and shutter speed.

Here's a disadvantage of using a camera's internal light meter: it only measure reflected light. More about this below.

Measuring Ambient Light

Ambient light is broken down generally into two types as far as photography is concerned, one is incident light and the other is reflective light. **Incident light** is the light falling on a subject. **Reflected light** is the light entering the camera lens bounced off the subject. A good quality, hand held light meter is the best way to measure light with the most options. I always try and measure incident light if I can. You need to hold your light meter near subject being photographed and point it toward the light source or camera lens. For reflected light, hold the meter towards the subject with you standing near your camera lens.

Here's how to remember measuring incident and reflected light:
- Incident light: measure at the subject.
- Reflected light: measure at the camera.

One modern meter I've been pretty happy with is a Sekonic Flashmate. It's simple, reliable and accurate. The little opaque half-sphere is used to measure incident light. Remember, to measure incident light you hold the meter close to the subject, then take a reading. You want the light that is falling on the subject.

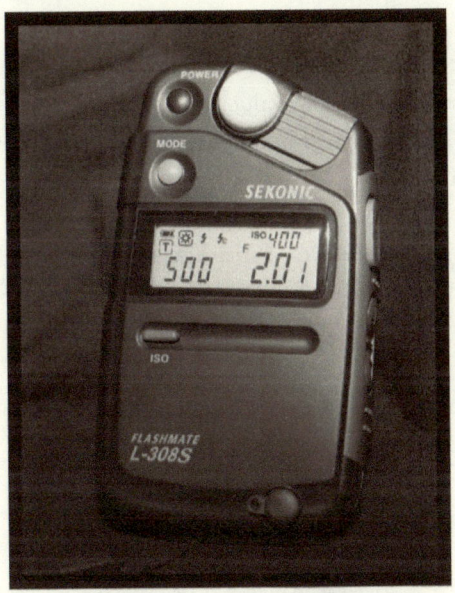

Sekonic Flashmate 308S

To take a reflected light reading, slide the dome so the lens is clear, point the meter towards your subject at your camera then take a reading. This is just like using the internal light meter in your camera.

As a side note, Ansel Adams strictly measured reflected light in his work. For his landscape images, this makes complete sense. What was he to do? Climb Half Dome and take an incident meter reading?

Light meters are not complicated, and there's only a couple of things you need to do to use one. First, set the ISO (or ASA) to whatever film speed you are using. As we know, for TRI-X, this is 400. If you have a modern light meter such as the Flashmate L-308S, then you need to set your initial shutter speed. Decide whether you're measuring incident or reflected light, push the button and take your reading to get the correct f-stop setting. If you want to vary the f-stop, just toggle the rocker switch up and down to new shutter speeds and the corresponding f-stop will appear.

On an older light meter, you still set the ISO or ASA but that's it. The older light meters have photocells and are usually always active. Meter for incident or reflective light using the methods cited above. Twist the outer dial until the needle is centered in the circle. This is called "match needle" metering. One thing I like about an older meter is all of the exposure settings are available at once. All you have to look at is the dial.

The shutter speed is usually on the outer dial and the f-stop in the inner. You can see at once all of the correct settings. Just pick an f-stop or shutter speed and read the corresponding value.

Set your camera shutter speed and aperture to the light meter settings, and you're ready to shoot.

Analog Studio Meters

It pays to learn how to use an analog studio light meter. These are more professional meters and have a lot of good features that you may or may not use, but it's good to know that they're available. I use a Sekonic L-398A. Studio meters cost more than simple meters like the L-308, as you would expect. Here's the L-398A.

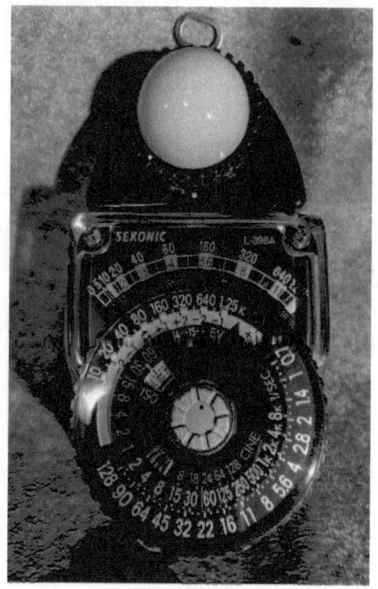

Sekonic L-398A

As you can see, the meter looks a lot more complicated to use. There are a few more steps to execute when taking a measurement., but once you get used to it, it's an easy meter to use.

The heart of the L-398A is the meter needle, which is common to all analog light meters. The needle responds to the amount of light entering the sensor. The sensor lies under the opaque half dome, called a lumisphere, so the L-398A is designed to read incident light. Here's an example of taking an

incident reading of a still life setup.

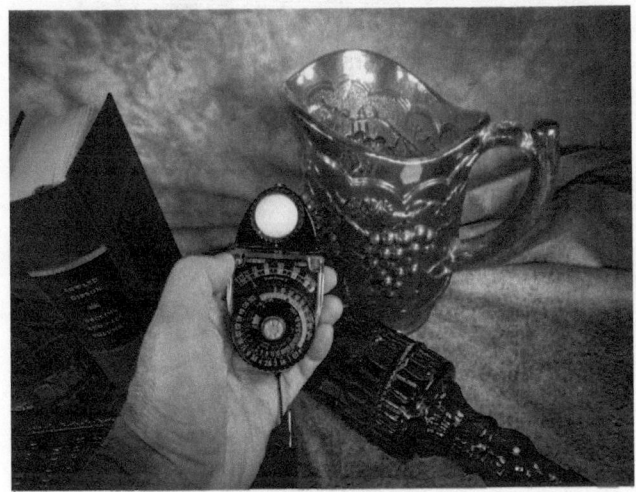
Sekonic L-398A

The basic measurement unit for the L-398A is in footcandles. A footcandle is a basic unit of illumination, which is all we really need to know. The footcandle scale acts as a base for all measurements on this meter. You take a reading by holding the meter toward your camera or light source and press the stopper button in the middle of the meter. This takes a reading and keeps the needle in position until you take another reading.

The needle points to a value on the footcandle scale. You read the footcandle value and adjust the scale mark to correspond to the same value on the inner footcandle scale. This calibrates the reading to all of the other readable values on the meter, such as shutter speed and aperture which are read from the outer dials.

The ISO is set by the rotating the inner dial. There is also a Cine scale for cinematography. The L-398A includes a pull out screen that is inserted between the light sensor and the lumisphere, which is used when the light is intense, such as a sunny day.

It may seem like a hassle using this meter but it only takes a couple of minutes to understand it. This is a powerful meter, and if used right, gives you a ton of exposure information. Here's the still life that was metered using the Sekonic L-398A.

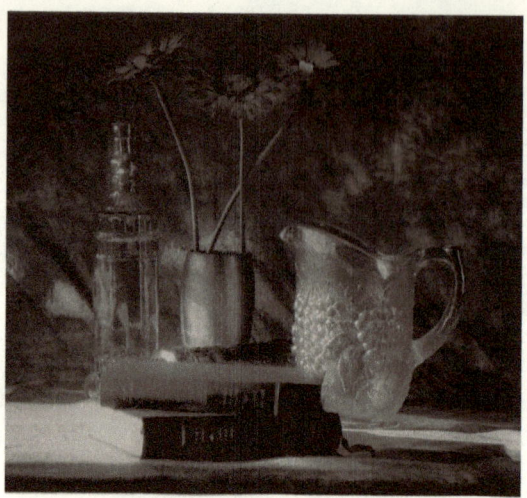
Metered with Sekonic L-398A

The Zone System Brief Overview

And when I say brief, I mean brief! Invented by Ansel Adams and Fred Archer, the Zone System can be incredibly technical and very labor intense to master. I'll just provide the very crude basics and you can use this as a springboard if you want to dive in and learn more. The Zone System takes visible light and breaks it into eleven partitions, from Zone 0 to Zone X, which is 10. The Zones are laid out from left to right. Zone 0 is pure black on the left and Zone X is pure white on the right, shown in the graphic below.

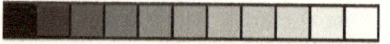

Zone V is middle gray. There are five zones to the left of Zone V and five to the right. Light meters are designed to read middle gray, and this can create issues with your exposure. You may not want to expose for middle gray- your prints may look dull and muddy and not make your subject stand out. Meter on some white snow and it will come out around middle gray in your negative. Using the Zone System, you the photographer decide what middle gray will be. Maybe it's a rock or tree jutting from a snow bank. If the tree is exposed for middle gray, then the snow will tend toward white.

One great aspect of the Zone System is the final image visualization by you, the photographer. Knowledge of the zones allows you to pick a given zone for exposure. Let's say you use your meter on a shot that provides a reasonably high range of tones or gradations of color. Your meter will

provide an exposure value for middle gray, Zone V. If you want to highlight an area that is in, say Zone VII, you will need to open your lens by two stops, or decrease your shutter speed by two stops. Each Zone corresponds to one f-stop. Using a conventional meter that measures incident or reflective light works okay, but to really isolate zones you need a spot meter. With the Zone System, you pick an inside area or shadow to begin with and work outward.

Ansel Adams wrote a series of books on the Zone System. They are very technical, but are well worth studying.

Spot Metering

The most acknowledged way to isolate zones entail using a spot meter. It makes sense. On a DLSR, a spot meter is usually provided along with other metering modes. Using a spot meter, you selectively get an exposure reading for a small area, such as 4 degrees, which accommodates the particular zone you are interested in and want to expose for. You use that exposure value on your camera. Spot meters are expensive and I don't own one, although I plan on acquiring one. I use the spot metering selection on my point-and-shoot as my hand-held spot meter. It works well. Again, most DSLRs all provide spot meters, but it can be a burden lugging around a heavy DSLR all the time. Point-and-shoots are small- as small as a hand held light meter or smaller. I use a Canon S110 and it works great, but any point-and-shoot that provides manual mode and spot metering will do.

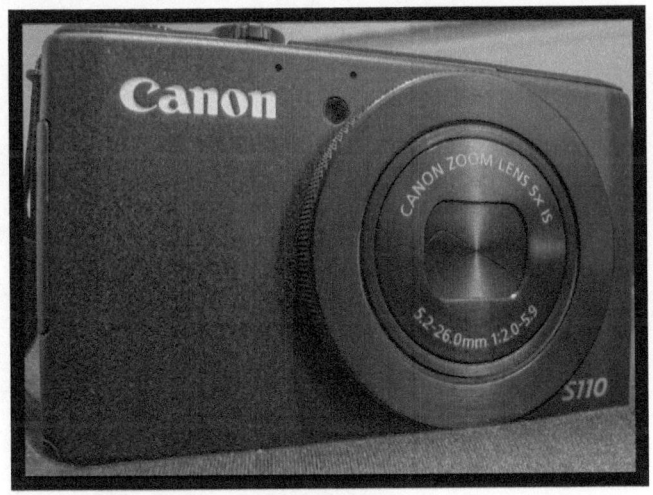

Canon S110

To use a point-and-shoot as a spot meter, you will first need to calibrate it. Set the ISO on your point-and-shoot to the film speed you are shooting and put it in manual mode. Set the metering mode to spot and meter a zone that you're interested in. Set your medium format camera shutter speed and aperture to these values. Record the exposures in your notebook and take your shot. Develop your roll of film and see how it turns out. If overexposed, you will need to drop down an f-stop or two. If underexposed, increase the f-stop.

This is pretty technical and is applicable of you want to shoot using the Zone System if you have a decent point and shoot laying around.

Camera Settings

Again, once the exposure is determined on your point-and-shoot, you need to set the aperture and shutter speed manually on your camera, all with depth-of-field in mind. Then you need to focus on the subject. Now you're ready to take the shot. So from your roll of 12 exposure you are now down to 11 after winding the film to the next exposure. If you are uncertain about the depth-of-field and exposure values or simply want to change them, increase your aperture to increase the depth-of-field and decrease the shutter speed by the same amount. If you are unsure of exposure, especially in high contrast conditions you should bracket your exposure by taking two more shots, one slightly overexposed and one slightly underexposed. This can use up a lot of film in a hurry. Remember earlier what we said about film being expensive? Just think before you shoot.

Shooting and Composition

No matter how expensive a photographer's equipment is, the easiest thing in the world to do is take a bad photograph. That's where basic knowledge of composition guidelines come into play.

Visualizing the Final Image

Visualizing a final image before taking a shot is one of the keys to producing a quality photograph. Frame up your shot in your viewfinder then step back and look at your intended composition. What mood do you intend? Is it dark and brooding, light and happy or somewhere in between? What is the relationship with your subject to its environment? Friendly, hostile, or indifferent? What is the relationship between the subject and you? Do you even have a subject? Where are the shadows? Where are the highlights? Really try and imagine looking at the final processed image.

Visualizing a final image takes a lot of practice and discipline. It makes you really think about your composition and reflect upon what meaning you want your image to convey. This is when you begin to approach art.

Composition

Shooting with a TLR such as the Yashica Mat 124G and the Holgas are by default in square format. The Mamiya 645E shoots in rectangular format. The guidelines of composition are a little different for each.

Light and Shadows

Ansel Adams said, "Expose for the shadows and develop for the light." The eleven zones aside, there are four general light categories, as shown in the figure below. The highlight, which is white, the core shadow, the mid-tone which is lighter than the core shadow, and the cast shadow, which tends toward black. Even though this is a massive simplification it's a good place to start imagining a final image as black and white film photographers. Starting

out by seeing the basic light and shadow attributes is a big step toward more sophisticated visualization.

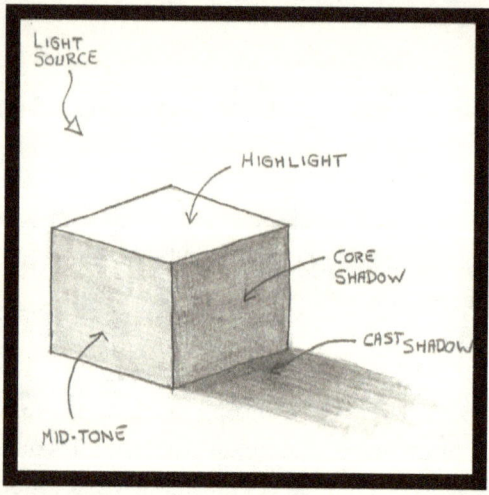

Sensitize yourself to really seeing shadows and light and classifying them into the four categories. This will help your photography immensely.

Filling the Frame

Filling a frame just seems natural for a square format image. This is particularly true for architectural shots, like the abandoned general store below. This goes hand in hand with centering the subject.

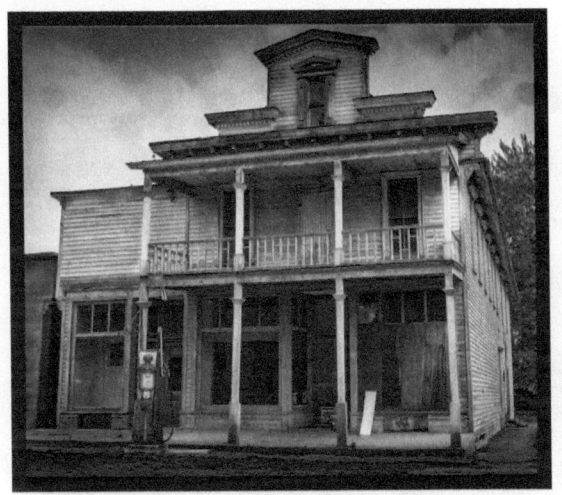
Yashica MAT 124G Tri-X at ISO 400

Here's another example of filling a frame.

Yashica MAT 124G Tri-X at ISO 400 1

Filling a square frame gives an image impact.

Centering the Subject

In this image, the central subjects are people on the escalator, illuminated from a spray of light separate from the people in the foreground and

background.

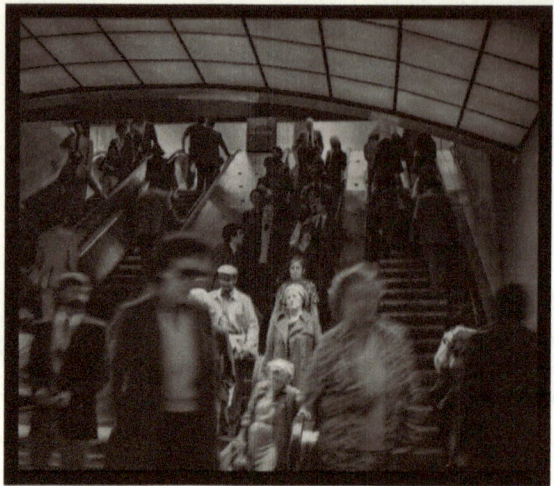

Yashica MAT 124G Tri-X at ISO 400 2

The shutter speed was pretty low in order to capture people in motion, as in the foreground. Remember, subjects do not have to be singular. Centering the subject works well for square format, not so well for rectangular.

Scale and Negative Space

Both formats lend themselves well to scale. What I mean by scale is the relationship of the subject with its environment. The image below shows a boy running along a path in a woods, dwarfed by the surrounding trees. The area surrounding the boy can be considered negative space, even thought there are objects in it. It fills out the image and is somewhat benign, helping the viewer focus on the boy and the path ahead of him.

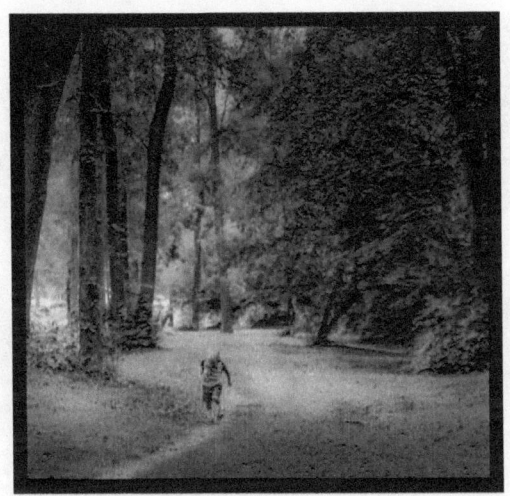

Yashica MAT 124G Tri-X at ISO 400

Scale and negative space also helps with meaning and metaphor. The boy running through the woods could be a metaphor for anyone bravely traveling through life, dwarfed by the world but focused on a clear path.

Utilize Diagonals, Leading Lines and Perspective

One or more diagonals cutting across a square frame enhances the composition. So does perspective. These guidelines or principles work for square and rectangular format. In this horizontal image, perspective is utilized and so is the Rule of Thirds. Placing the girl with the notebook in the lower third of the image makes her a focal point.

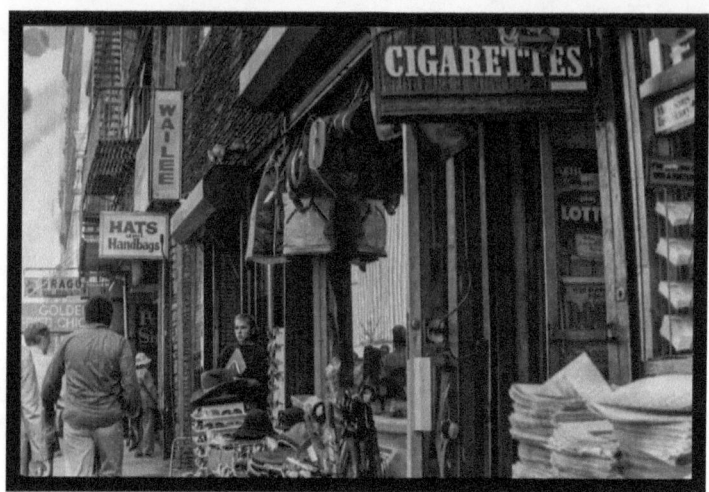

Yashica MAT 124G Tri-X at ISO 400

Rule of Thirds

The Rule of Thirds is one of the foundations of rectangular composition. Imagine a grid over the viewfinder that divides the image into nine partitions, as shown below.

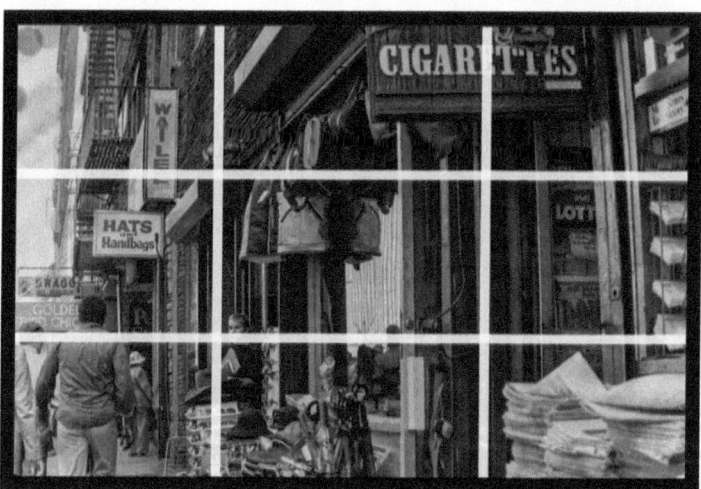

Yashica MAT 124G Tri-X at ISO 400

According to the Rule of Thirds, the focus of a composition should be at one of the intersecting points on the grid. In this image, the girl with the notebook is the subject, and she's located at the lower left intersection of the

partitions.

She's balanced by the cigarette sign, which is roughly near the upper right of the photograph. Having the cigarette sign just outside of the intersection does not focus attention on it, taking away from the girl. The Rule of Thirds is a powerful tool. You will be amazed at how your photography improves after you practice with it. After a while, it will be instinctive.

Use the Rule of Thirds cautiously with square format photography since it applies mainly to rectangular images. As a side note, the square format Yashica Mat 124G comes with a grid like the one above on the focusing screen. Unless I plan on cropping an image rectangularly, I just use the center frame to box in the main subject.

People

What do most great photographs have in common? People. Look at The Americans by Robert Frank. Check out Welsh Coal Miners by W Eugene Smith or Wall Street by Paul Strand. They all contain people. If Wall Street didn't contain the people walking casting long shadows, it would be mundane and nondescript. People make all the difference in a photograph.

The image below would lack energy without the woman walking. The woman on the left is balanced by the pillar and sign on the right, where the subject is the woman's legs sticking out from the doorway.

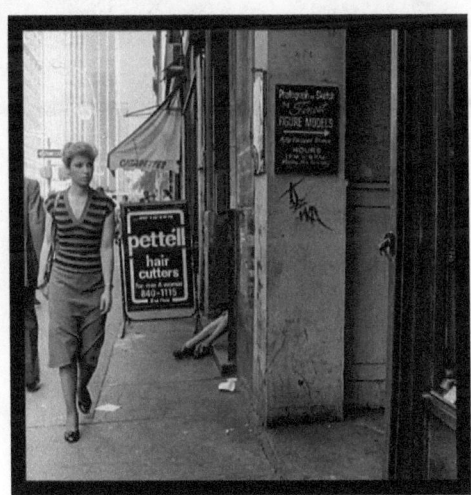

Yashica MAT 124G Tri-X at ISO 400

So, can you get into hot water legally photographing people? It depends where you live. Firstly, I'm not a lawyer but this is what I understand. In the United States, you can photograph who and what you want in public places, or in places where photography is allowed. This means you can shoot on the streets with no issues. Regarding private property, you need permission to shoot inside or on the property, but you may photograph the property from a public place. You can also shoot the general population, accidents, fires, children, celebrities, law enforcement officers, criminal activities and arrests. You do not have to explain what you are doing to anyone, including police officers, but just make sure you are not obstructing public officials in the discharge of their duties. No one can take your camera equipment or images without a warrant.

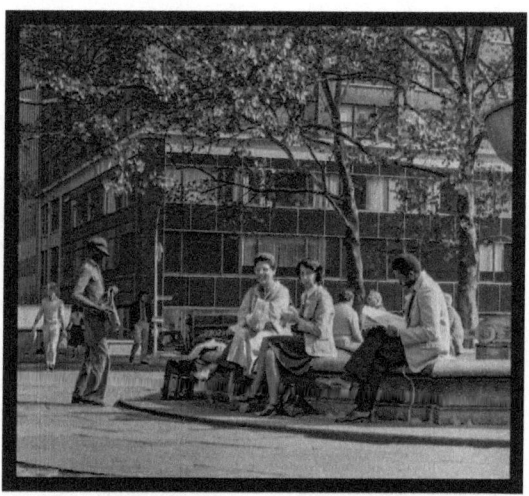

Yashica MAT 124G Tri-X at ISO 400

I've never had a problem shooting on the street. For the most part, people are indifferent and you feel almost invisible. You may have other photographers come up to you and chat, especially if you have a medium format film camera, but that's about it.

Yashica MAT 124G Tri-X at ISO 400

So what about publishing photographs with people in it? Again, from my understanding, if you are not using a likeness of a person to promote a product, service, idea or thing, or to disparage the person, a model release is not required. Again, I'm no lawyer so do not take what I say for gospel, but I believe that applies to the type of photographs this book conveys. We're producing artistic and street photographs, not opinions or advertisements for products or services.

Putting Principles Into Practice

As stated earlier, film is expensive, and it's pretty extravagant using it to practice composition. If you haven't utilized many of the techniques outlined in this chapter, here's a suggestion. Scout locations and use a digital camera. I do it all the time for a serious shoot. Use it to practice for the composition techniques, such as diagonal and leading lines, filling the frame or the Rule of Thirds.

When you transfer your images to your computer convert them to black and white and crop them so they are square. See what you did right, and what you did wrong. If you have a set of images that sparkle, go back and shoot it with your medium format film camera. Is it a lot of work? Yes it is, but it's worth it, especially if you're just starting out or are really serious about your work. I always carry a point-and-shoot with me when I go shooting with a film camera, and I'll take some test shots before hand to help hone in on the image I visualize. A good point-and-shoot is a handy tool, for light metering

and image testing. In the days before digital, professional photographers used to take Polaroids of their subjects first, to test lighting and composition. Using a point-and-shoot is no different.

If you really want to get good, spend a day shooting each of the composition guidelines one at a time. One day shoot for negative space, another for scale, another for diagonal and leading lines. Do this for a few weeks. Use your point and shoot and if you run across something great, shoot it with your film camera. After time, all of the guidelines will be internalized and you will subconsciously apply them to your compositions.

I do not want to fail to mention this: name your photographs, at least in your imagination. It isn't pretentious or pseudo-artsy. It's important. It lends focus and meaning to your image and subject. Above all, it make your image *intentional*. If it comes to mind, try and think of a title for your image while you shoot it. It will help you extract more meaning out of every shot.

Finally, to be a world-class film photographer you need to work, and work hard. You aren't taking snapshots at a birthday party, you're creating art.

Developing Negatives

Developing negatives is deeply foreign to most digital photographers. Film is made of plastic that has a thin coating of emulsion. The emulsion changes when exposed to light. There are microscopic silver salt crystals suspended in the emulsion that turn to silver metal when exposed to light. The more light that hits the film, the more dramatic the change. This produces what's called a latent image on the film.

Getting Started

The first thing that you will need is a developing tank and reel, which are almost always sold together. A developing tank consists of the tank itself, a reel in which film is wound, a cover and a top. The cover is light poof and the cap covers the opening where developing chemicals are poured in.

There are generally two types, stainless steel and plastic. Of the plastic variety, there are manual and semi-automated reels called Patterson reels to wind film. With stainless steel reels, the film is wound from the inside out. Once the film is loaded, the development process can begin.

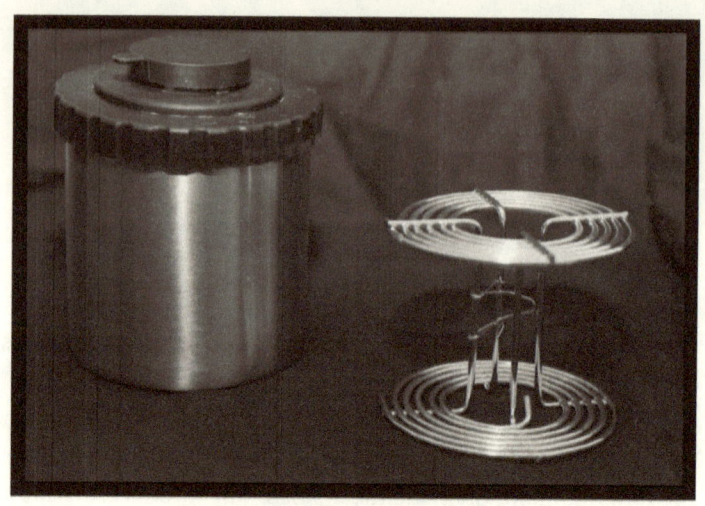
Stainless Steel Developing Tank

Loading Film Reels

Many photographers swear by stainless steel tanks and reels. They are sturdy and are practically indestructible. I own a stainless 120 tank and have a 35mm tank that I bought thirty years ago which I still use today. Film is loaded onto a stainless steel reel from the inside out, as shown below.

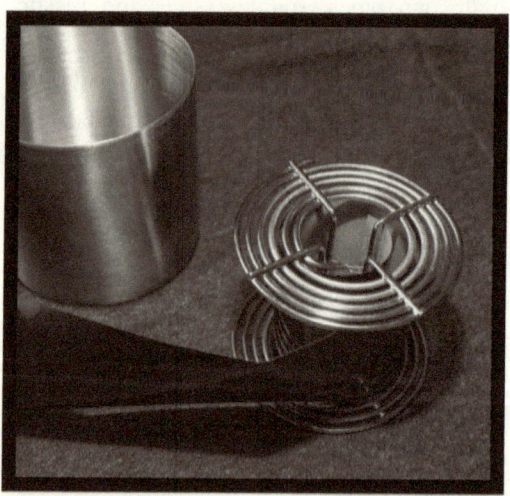
Stainless Steel Developing Tank

Here's another tank that I use. It's an old, plastic FR Special developing tank, vintage 1969.

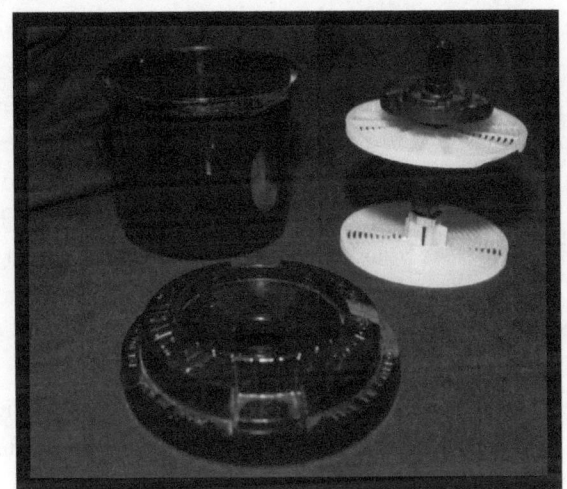

Plastic Developing Tank

Film is loaded onto a plastic reel from the outside in.

Plastic Developing Tank

Loading a Developing Reel

For me, loading film onto a developing reel is the hardest part of medium format film photography. This is something you have to continuously

practice, because this has to be done in **complete darkness**. Most film photographers use a lightproof changing bag or utilize a completely dark room.

Here's how to practice loading film, and you should proficient at loading both types of reels, plastic and stainless steel if you have one of each. Sacrifice a roll of film and load the type of reel you have in daylight. Look at the reel while you are loading or winding to get an initial feel for it. When you feel comfortable with that close your eyes and load the reel. This is exponentially more difficult. Check your work when you're done. The very last thing you want to do is have the film stick together on the reel. If it does, there will be no image, just a gray blob of emulsion.

Practice with your eyes closed until you really get the feel for it. When you feel confident, load the reel using a changing bag or in a completely darkened room several times to get the feel for that. If you are getting consistent good film loads, then you're ready to load an exposed roll of film.

Does this sound like overkill? Maybe yes, but think about this. You went on a shoot and exposed a few rolls of film. You worked hard to get your shots, applying your eye, knowledge and the rules of composition. You may have some really spectacular images laying latent on your film. Do you want to blow all of that by incorrectly loading your film onto a developing reel? Your outing will be pointless and all of your effort will be for nothing. For me, this is the most critical phase of film photography and there's no going back. If you do it wrong, you can't fix it.

Make sure you have all the tank parts with you when you load film. The last thing you want to do is to forget the cover when you're in a darkened room and the film is on the reel. I did this a few times in my early film days, and you learn not to forget any of the developing tank parts, fast.

I can't stress this enough. Practice, practice, practice loading your film reel. This is a true case where practice makes perfect.

Processing Negatives

Now comes the fun part. Your film is successfully loaded on a stainless or plastic reel. It's time to develop your negatives. Before you dive in, there are several things you need to do. The first is get all of your equipment together. Here's what you will need:

- A tray to fill with water at 68 degrees F (20 degrees C). Developing chemicals work best around 68-70 degrees Fahrenheit. Placing your chemical containers in a tray with 68 degree water will help stabilize their temperature.

I use a 10x12 inch print developing tray. Don't rush it, because you need the water temperature to be right.
- A darkroom thermometer. Nothing beats a Kodak Darkroom Thermometer. I use the yellow vintage type. You can use any thermometer, just as long as it's big and you can read it. Legacy PRO-6 thermometers fit the bill.
- A 20oz graduated cylinder for accurately mixing chemicals. More than one is handy.
- A negative developing tank, stainless steel or plastic- your preference.
- Dark bottles to store chemicals, at least three. Delta Datatainers are good.
- A negative Squeegee. This is optional and I rarely, if ever, use one. A lot of photographers swear by them, though.
- A small funnel for pouring chemicals into bottles. This is optional if you are just mixing small amounts of chemicals. They pour just fine into the bottles from the graduated cylinder.

Distilled Water

It's wise to use distilled water to mix your chemicals with. Tap water may be inconsistent month to month. Distilled water is not. Optionally, you can use photo-flow, which is clarifier and removes water spots from your negatives. Some photographers do not bother with this. I do, since I do not want to risk my negatives having spots.

Chemicals

As you can see, there really isn't all that much to buy in order to start developing negatives, and a general black and white development recipe is at the bottom of this chapter. For all of the steps, except the final wash, the film must stay light-sealed in the development tank. If exposed to light, your negatives will be ruined.

Now on to the chemicals and what they do.

Developer

Developer is the first chemical used, and there are a lot of different kinds available. Kodak D-76 is a popular, workhorse developer, and is considered a standard by a lot of photographers. D-76 comes in a 14.6oz powder packet. One packet makes one gallon of developer. Kodak HC-110 is another good developer. I also like Ilford Ilfosol 3. HC-110 and Ilfosol 3 come in liquid form. Developer is diluted with water in varying proportions. The

proportions vary depending on the developer. Ilfosol 3 is 1 to 9, meaning one part developer to nine parts water. D-76 is 1 to 3. It's probably best to find a developer you like and to use that exclusively. I bounce between D-76 and Ilfosol 3, but lately have been tending toward Ilfosol 3.

I suggest trying a few developers and stick with the ones that give you the best results.

Stop bath

Stop bath goes in the developing tank right after the developer is poured out. It stops the development process. Some photographers skip this step and just use water. I like to make sure the developer is stopped cold, so I always use stop bath. Stop bath proportions are generally are 1 to 19, that is one part stop bath, nineteen parts water. Stop bath can be reused.

Fixer

Fixer "fixes" the film, which stabilizes the film by getting rid of any unexposed silver halide on a roll of film. All that's left behind is the metallic silver on the film. I generally keep my film in fixer for at least ten minutes. Fixer can also be reused.

Hypo Clearing Agent

Hypo clearing agent reduces the wash time. A lot of photographers use this, but I rarely do. I prefer to increase the final wash time. On the other hand, using hypo clearing agent reduces the wash time and allows you to conserve using water, which is always good.

Photo-Flow

A drop or so of photo-flow in a final rinse for thirty seconds also helps stop water spots from forming on your drying negatives. This is optional, but I use it just to be sure. Since you only add a drop of photo-flow to your developing tank, a bottle of photo-flow lasts almost forever.

Developing Variables

Although there are a few variables in the development process, it follows a pretty much standard sequence. The basic sequence is 1) developer 2) stop bath 3) fixer 4) wash. Adding photo-flow and intermediate washes are added in the mix, but those are pretty simple and vary according to an individual photographer's technique and preference.

The main variables are the film used, developer used, development time and temperature. Development time means how long your film is immersed in developer. D-76 with TRI-X at ISO 400 at 68 degrees F is around eight minutes. D-76 with T-Max 100 Professional film at ISO 100 is seven minutes. You need to check the film type and developer to get an accurate development time. Ilfosol 3 development time with TRI-X at ISO 400 is seven and a half minutes. As mentioned before, experiment with developers and land on one or two you like.

A Note About Pre-Washes

A lot of photographers pre-wash their negatives. That means soaking the negatives in the development tank for around 4-5 minutes. The purpose is to make it easier for developer to spread on the film once it's added. I always pre-wash my negatives.

Temperature

Development time is heavily based on temperature, and the ideal temperature to develop negatives is 68 degrees F or 20 degrees C. All of the development times here are based on 68 degrees. That's why you need a thermometer and tray filled with water to hold your chemical containers. I fill my tray with as close as I can get to 68 degrees and let my chemical containers sit in them. The thermometer sits in the tray or the graduated cylinder I'm currently mixing chemicals in and I monitor temperature with that.

Developing Sequence

Here is a general sequence for developing negatives. If you wind up using a different developer, note that and the developing time. Make sure your water and chemicals are at 68 degrees F or 20 degrees C. I have this developing sequence available as a PDF you can download at https://mediumformat.pictures/developing-negatives-checksheet for download.

Developer

1a) (Ilfosol 3) 7 1/2 minutes - agitate for about 30 seconds every 30 seconds. (Agitate means rock gently upside down in a stainless tank or swish with the agitator in a plastic tank).
1b) (D-76) 8 minutes - agitate every 30 seconds

Stop bath

1 minute. Tap on the tank in 15 one second intervals to dislodge any bubbles.

Wash

Wash in running water for 1 minute.

Hypo Clearing Agent (optional)
1 minute.

Fixer

5-10 minutes in fixer. I always fix for 10 minutes. Tap every once in a while to dislodge any bubbles.

Wash

At this point you can take off the film tank cover.
20 minutes. I always wash for 20 minutes. All this entails is letting a trickle of water run into the open tank.

Photo-flow

2 drops - I empty the tank, fill it up with distilled water and add the photo-flow. Let it sit for about a minute.

Dry

Hang the negatives and let them dry for at least two hours. Use some form of weight on the bottom of the filmstrip, like a plastic clip you get at the dollar store.

That's it. Once you develop a couple of rolls of film it will seem like old hat. Just as a reminder, this is a general sequence that I use. There are plenty of developing sequences or recipes available on the Web and on YouTube. The key is to experiment and stick with what works best for you.

Cutting Negatives

Cut your negatives in strips of four. Most scanners have plastic carriers that fit four exposures. Trust me, this is a lot easier than trying to place individually cut negatives into an enlarger carrier. There are a variety of negative storage media available, such as archival sleeves. I store a lot of mine in simple envelopes.

Developing negatives is where the rubber really meets the road in film photography. All of your subsequent images are dependent on good negatives. Practice developing negatives with diligence and discipline.

Push Processing Negatives

On a DSLR, you have the luxury of varying ISO for every exposure if you want. Not so with a film camera, but the ISO rating of your film is not cast in stone. Even if your film is rated at ISO 400, you can "push" it to ISO 800 which is one f-stop higher, 1600 which is two f-stops higher, and possibly upward. How is this done? By altering the ISO setting on your camera and increasing negative developing time. Unlike a DSLR, if you decide to push your film from 400 to 800 ISO, the entire roll must be exposed at 800 ISO.

Here are the steps to push ISO 400 film, such as TRI-X to 800:

First, set the ISO setting on your camera to 800. This will fool your camera into thinking more sensitive film is loaded.

Second, meter your composition and shoot. When pushing film, detail is lost, so meter and expose for the shadows. Also, if you're using a hand-held light meter, make sure you set the ISO to 800, otherwise you'll be out of sync with your camera settings and your exposures will be way off.

Third, increase the negative development time according to the developer you use. For example, pushing TRI-X ISO 400 to one stop (ISO 800) in Ilfosol 3 developer, the development time is increased for 7.5 minutes to 10.5 minutes.

That's really all there is to it, although there are a few caveats. For one, your pushed negatives will have less detail and more grain than developed at its native speed. For another, once you change your ISO setting on your camera, you can't go back. You can't shoot one exposure at ISO 400 and another at ISO 800. Depending on negative development time, one of the exposures will be bad.

Personally, I tend to keep my negatives in developer for an extra few seconds, just to give it a contrast and grain kick since that's what I like. As

with all film photography, it takes some experimentation to get your exposure and development process dialed in to where you like it.

Pulling film is the opposite of pushing film, and is used in some extreme cases to reduce contrast. I have never pulled film and I do not any other photographer who has. I just don't find it useful.

The main takeaway regarding ISO is that it is really not truly fixed. You can increase the ISO by push processing your film but there are side effects, mainly increased contrast and graininess. If this is what suits you, push away.

When Things Go Wrong

A lot can go wrong when you develop negatives, and they probably will. Especially when you're just starting out. For me, most of my mistakes were in loading the film on the developing reel, fixing and washing.

Curly Negatives

Your negatives may not have been washed long enough or have not dried long enough. I hang my negatives vertically with two clips, one at the top and one at the bottom for weight. Put the heaviest clip on the bottom. Negatives may curl in the drying process but that's okay. Let them dry for at least two hours and they straighten out. If they are still curly, you can still wash your film again. Make sure you increase the wash time on the next roll of film.

Negative Damage and Uneven Development

If the surface of your negatives have little curvy spots on them, the film was not evenly rolled onto the developing reel. If film has stuck together on the reel, you'll wind up with gooey gray. This is why it's supremely important to practice winding film onto a developing reel.

If you use a squeegee, you run the risk of streaking your film. I have a squeegee, but I never use it.

If you have water spots on your dried negatives, next time make sure you use photo-flow the next time you develop a roll.

Cloudy Negatives

If your negatives are cloudy, then issue is probably the fixer and/or fixing time. If you've been reusing your fixer, change it. If your fixer is good, then you've not left your negatives in the fixer long enough. Increase your fixing time by several minutes. All is not lost if your negatives are cloudy. You can wind your film on the developing reel and re-fix them. Just fix them again for

the same fixing time, then wash for ten minutes.

Thin Negatives

First, make sure you exposed your film correctly. Is the ISO setting correct on your camera? Forgetting to set the ISO when using different speed film is a common mistake, so get in the habit of immediately setting your ISO before you load a new roll of film. f you're using a hand held light meter, then makes sure the ISO setting is the same as the film.

If the ISO was correct, determine whether the image was exposed correctly. Thin negatives are dark, meaning they are underexposed. This is where keeping a notebook when you start out is a good idea. If your exposure values were correct, and the whole reel of film is dark, then the film is underdeveloped and your development time, mixture or temperature was probably incorrect. Film development is temperature sensitive, so take care that your developer temperature is at 68 degrees F or 20 degrees C. Make sure your development time is spot on, and make sure your development mixture (unit of developer per unit of water) is correct. Chances are your development time was too short.

Thick Negatives

A lot of the conditions for thin negatives apply to thick negatives. Thick negatives are overexposed. Check your ISO and exposure data for your roll of film. If they're okay, then your film is overdeveloped. Make sure your development time is correct and the development mixture. If too much developer is in the mixture, this will overexpose your negatives. Two other things to get under control are agitation and temperature. Do not aggressively agitate your negatives. Again, make sure your developer temperature is at 68 degrees F or 20 degrees C.

If you work with film, you will run into these pitfalls once in awhile. Learn from them and maybe keep this list handy to see what went wrong so it won't happen again.

Photographing Images Digitally

In this chapter we photograph negatives then process them in Lightroom. Unlike the long, stressful process of developing negatives, these techniques are very straightforward.

Photographing Negatives

In order to photograph negatives you will need a light box and a macro lens. To photograph the negatives in this book I used a Canon 5D Mark III full frame sensor DSLR and a 24-70mm zoom with macro capability. You don't have to use a high end camera like this- just about any DSLR will do. What you will need is a macro lens, or a lens that has macro capability. Many lenses with macro capability are pretty reasonable. I do not have a dedicated macro lens per se. I just use my 35-70mm zoom with macro and that works just fine.

If you don't have a macro or macro-capable lens, you can buy a reversing ring for your lens for about $15. What a reversing ring does is that it allows you to mount your lens backwards on your camera. You mount the reversing ring on your camera, then thread your lens onto the ring, backwards. The camera must be in Manual mode in order for a reversing ring to function properly. Put your camera in live view mode and go from there. Also check your histogram for proper exposures.

Exposure

You will need to experiment around with exposure a bit. The light coming from the light box should be enough to keep your ISO pretty low. I try to keep my ISO at 100 and maybe 200, but nothing above that. Again, it's preferable to have a macro capable lens, but a macro reversing ring will do. There is always the alternative of scanning your image.

I use two setups for photographing negatives. The first uses a tripod. Note

that the negatives are not held down in this shot. When I'm actually shooting, the light box is turned on, of course, and the negatives are held down with blocks or a home made mask of some sort. Also, I try and match the angle of the light box.

Light boxes are inexpensive. I bought one new for a little over $40. It's the right size for shooting negatives and it's LED illumination is nice and even.

Using a tripod gives you maximum stability. To reduce vibration, you can use a cable release and mirror lockup.

Negative Shooting Setup

The second setup uses a simple pair of wooden blocks.

Negative Shooting Setup

I rest the camera on the two wooden blocks and take the exposure. I set the shutter to 1/30sec and the aperture to f/13, manually focus and shoot. This has worked out pretty well for me. All but one of the negatives in this book were photographed. One was scanned and I can't really tell the difference. The f-stop value really doesn't matter, since the image you're photography lies on a plane, the flat negative.

Scanning Negatives

If neither of these setups appeal to you, scanning negatives a great alternative. I would hazard a guess that the majority of photographers scan their negatives for processing. I also plan to scan more and more negatives in the future. Negative scanners come with holders that keep your negatives flat and in place when you scan them, and provide software to turn the scanned negative images into positives. The holders usually hold a strip of four 120 exposures. There are many scanners available for negatives, starting at a little under $200. A negative scanner is a good investment.

Shoot or Scan?

Scanning has its advantages with resources such as selectable high resolution, automatically turning the negative scans into positive images that you can go on to use any image manipulation applications and further process. The scanned formats are tiff and jpeg. A big advantage is that you do

not have to use Lightroom for turning negative images into positives. With the positive images provided by a scanner, you can use low or no-cost applications such as Pixelmator or GIMP to process and refine your images.

If you photograph your negatives through, there's one advantage: shooting in RAW. If you're unfamiliar with shooting in RAW with digital cameras, RAW is just that. It is not an image, it's the raw data from the sensor that makes up the image. Think of RAW as a digital negative. When you shoot in RAW, you can change the exposure, white balance and lots of other characteristics that you cannot in jpeg or other forms. RAW is un-encoded, where jpeg and tiff are. There are applications, such as Adobe Camera RAW that allow you to manipulate the image parameters before you process them. Think of that as like developing a digital negative.

Transferring Images

Now that your images are photographed, we can import them into Lightroom. Just import the negatives the way you import any other set of images.

Processing Images

Now that your images are photographed and imported, it's time to turn the negatives into positives and process them in Lightroom. Lightroom has all of the tools you need to produce spectacular results. We will go through the steps, one by one. This is the image we will process in this chapter.

First, select the Development module for your negative.

Image in Lightroom

The very first thing to do is reverse the tone curve. The Tone Curve is on the right side of the development tools panel. Make sure that Point Curve: Linear is selected. What we need to do is drag the right side of the curve to the bottom and the left side to the top. This will turn your negative into a positive.

First, drag the left handle all way up. Again, make sure you have Point Curve: Linear selected. The image will turn completely white.

Second, drag the right handle all the way down. This is exactly the opposite of the default tone curve.

You will see a positive image appear.

Your negative is how a positive and ready for processing. That is all there is to it to basically convert a negative to a positive in Lightroom.

Processing Your Positive

If you've installed the NIK collection and specifically Silver Efex Pro, then right click on the image and select Edit In -> Sliver Efex Pro. I'm using Version 2, but you may be using a different, later version.

Once you're in Silver Efex Pro you have a large selection of presets to

choose from on the left of the display. Preview them and select whatever suits your image the best. Select Save and you will be returned to Lightroom with the preset active.

I generally like a high-structured image so that's what I selected. Remember, your preset is just a starting point for further development. The tools below are used to fine tune your image. I start with the Highlights, Shadows, Whites and Blacks sliders to get more contrast. Then I almost always increate the clarity. You may need to adjust the Contrast and Exposure for your image. In the upper right corner is the Adjustment Brush, which is worth its weight in gold.

There are presets available to dodge (increase exposure) and burn (decrease exposure) that I personally use a lot. This allows you to paint over areas of your image to make the areas brighter and darker. Carefully dodging and burning adds contrast, quality and depth to black and white images.

With just a little processing with the controls and dodging and burning this is the final image.

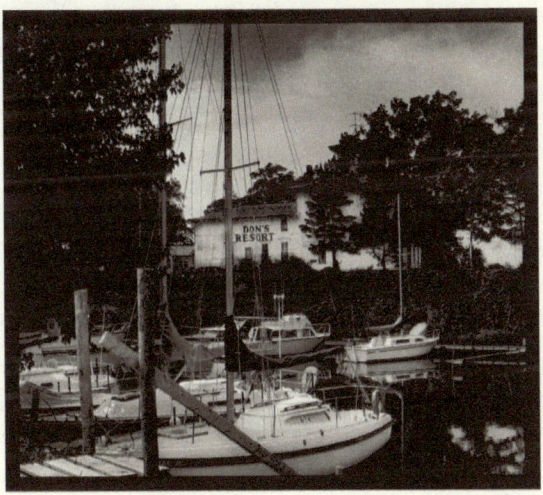

Negatives vary so widely in exposure and contrast, making it impossible to cover every situation and example. After you get used to shooting, importing and processing your negatives it will become an automatic process for you. You can then concentrate on what you want you want your image to convey.

If you don't get perfect results right away, just tinker around with the adjustments. After some practice you will be cranking out great black and white images in no time at all.

Making Prints Digitally

In most cases you will be printing your black and white images from your computer to an ink jet printer on a variety of papers. We need to talk about monitor calibration. Have you ever processed an image in a software application such as Lightroom or Photoshop, printed it and the colors do not match those on your display? This is disappointing and wasteful. The issue probably is that your monitor is not calibrated. You may think the images look good, and they might to you on your monitor, but they may be way off.

A good investment is a monitor calibrator if you print frequently. It will cost you close to $200 for a middle of the road calibrator. A lot of casual photographers believe that monitor calibrators are only needed if you're printing color images. Not true. Basic to monitor calibration is pure white and pure black. I know if my monitor is not calibrated, my printed blacks have an annoying magenta tinge to them. The ultimate goal here is to print awesome, accurate images. You will typically not be able to do this if you monitor is not calibrated.

Setting Up a Darkroom

If you want to want to set up a darkroom to develop prints with an enlarger, You need to have a dedicated, light-proof space. Many photographers section off parts of their basements, if they have one.

You will need an enlarger, a paper holder, developing trays, an easel to hold the paper, a thermometer, a safelight, tongs and a timer as an absolute minimum. If you don't have a dedicated darkroom space, setting up and tearing down a temporary darkroom is a lot of work. Printing negatives is akin to developing film. First you expose the negative onto the paper, put the paper in developer, stop bath and fixer. The final step is washing the prints.

You need to pay attention to enlarging lenses. Like most cameras, enlarger lenses are interchangeable. The standard enlarger lens for medium format is 80mm. Also, most enlargers come with 35mm carriers. You need to make sure a 120 film carrier is available for your enlarger.

If you decide to be a real purist and traditionalist, my hat's off to you. I had a darkroom for many years and enjoyed every minute spent in it.

Great Black and White Photographers

Black and White film photography has a rich history. How better to learn than study the masters? In this chapter we take a look at some of the great black and white photographers. There are too many to list, and it would take volumes to identify them all. The photographers and photographs listed below are the ones that I really admire and have learned a great deal from.

There's a short description of each of the photographers, what they shot with and what I believe make them stand out. To learn more about the photographers and to see their work, use Google, since most of the images are copyrighted and cannot be reproduced here. At the very least, you may see some photographers listed that you haven't heard of and can check out their work. No particular order was chosen, so don't confuse order for preference.

W Eugene Smith

W Eugene Smith, born in 1918, started his professional life with Newsweek, Colliers, LIFE, The New York Times and other publications.

He really made his mark as a photojournalist in World War II, and was badly wounded on Okinawa. He later worked for Magnum and produced stunning images and photo essays. Smith died in 1978. W Eugene Smith was a supremely humanistic photographer.

Regarding cameras, from the research I did, Smith pretty much used what was available to him. When he had a difficult time with bills, he would pawn his cameras. When fresh money came it, he would buy whatever caught his eye. There are photos of Smith with lots of different cameras, primarily 35mm rangefinders, which are still popular for street photography today.

Why I Like W Eugene Smith

I like W Eugene Smith above all for the humanity expressed in his striking

photographs. Much more than a photojournalist, his images range from maimed soldiers to innocent children and convey human joy and dignity to human suffering. Smith seemed to be a fearless photographer, as evidenced by the severe wounds he suffered in World War II.

Images such as The Walk to Paradise Garden and Country Doctor are sheer classics. The more I study Smith's work, the more in awe I am.

Outstanding Photographs
Country Doctor
Spanish Village (photo essay)
A Man of Mercy (photo essay)
Welsh Coal Miners
The Walk to Paradise Garden

Paul Strand

Paul Strand, born in New York City in 1890, was one of the early Modernist photographers. Strand used an 8x10 view camera for the bulk of his work. Around 1920 he began using the camera politically with a progressive undertone. Eventually he gained interest in making films and worked for a considerable amount of time in cinematography. Married three times, Strand eventually settled in France, where he died in 1976.

Why I Like Paul Strand

I like Strand's abstract work, and Wall Street is one of my all time favorite photographs. To me, it typifies a sense of cold, indifferent institutional power. Yes, Strand was a humanistic photographer with a progressive bent, but his images lack a little of the warmth and passion of W Eugene Smith, in my opinion. To me, his groundbreaking work was more in the abstract, taking simple structures such as stairways and fences, observing the leading lines, shadows and contrast, and producing incredible images.

Outstanding Photographs
Wall Street
The Family
Abstraction, Porch Shadows, Connecticut
Young Boy, Gondeville, Charente, France

Alfred Stieglitz

Alfred Stieglitz was born into a wealthy family in 1864 in Hoboken, New Jersey. Stieglitz was a self-taught photographer and owned a small business named the Photochrome Engraving Company, bought for him by his father. It's well acknowledged that Stieglitz's largest contribution is legitimizing photography as an art form. Stieglitz was a perfectionist in his work, and later married the artist Georgia O'Keefe.

An interesting fact is that Stieglitz was the first photographer to have his work displayed in a museum, the Boston Museum of Fine Arts, in 1924. Stieglitz used 4x5 and 8x10 view cameras, common for their time. Alfred Stieglitz died in New York City in 1946.

Why I Like Alfred Stieglitz

I like Stieglitz because he was a pathfinder. Driven by a passion for photography, he helped move it from a practical backwater to a legitimate art form.

Outstanding Photographs
Winter, Fifth Avenue
The Terminal
The Last Joke, Bellagio
The Steerage

Edward Weston

Edward Weston, born in Illinois 1886, was a groundbreaking photographer when it came to abstract shape and form of natural objects. Peppers, flowers, bananas, sea shells, nudes, Weston images are rich, high contrast and full ranged. Weston was incredibly prolific and spent that last years of his life supervising printing of his work.

Weston used a variety of cameras, including a 11 x 14 Graf Variable which is massive, an 8x10 view camera and a 4x5 Auto-Graflix. You can get a decent 4x5 Graflix for around three to four hundred dollars.

Weston was a prolific notebook keeper, called Daybooks. These have been published and Edward Weston, the Flame of Recognition is available at most libraries. Edward Weston died in 1958 in California.

Why I Like Edward Weston

Although Strand pioneered abstract work, Weston made it much more organic. Whenever I see a contemporary close up of a vegetable, fruit or abstract nude, I think of Weston. I also like Weston because he was a prolific writer.

Outstanding Photographs
Nude, 1936
Cabbage Leaf, 1931
Nude, 1931
Church Door, Hornitos, 1940
Diego Rivera, 1924

Vivian Maier

If there is ever an enigmatic photographer, it's Vivian Maier, born in 1926. Working as a nanny the bulk of her life, Maier shot in the streets with a Rolleflex TLR on her days off, capturing people and places. Maier was unknown until 1978 when a man named John Maloof bought 30,000 of her photographs for four hundred dollars. Once published, Maier has become a street photography sensation, and for good reason. Her work was incredible.

As far as I know, Maier used a Rolleflex TLR, which is similar to the Yashica Mat 124G. Maier shot mainly on the streets of New York City and Chicago. Impoverished, Maier died in 2009 in relative obscurity.

Why I Like Vivian Maier

Vivian Maier was driven, shooting a hundred thousand rolls of medium format film. She shot constantly on her days off as a nanny. This to me is the hallmark of a true artist. I believe Vivian Maier shot in the streets not because she wanted to, but was compelled to by some inner force.

Outstanding Photographs

Since Vivian Maier was virtually unknown as a photographer, her photographs aren't named as far as I can tell. The best data there is are dates for her photographs, and those can be sparse. On http://www.vivianmaier.com there are several galleries to look through, all filled with great street photography.

Diane Arbus

Diane Arbus, born in 1923 in New York City, had a gift for capturing people on the fringe of society. You see an underlying sleaziness but vulnerability in her photographs of transvestites, aging glamor queens, strange children and circus freaks. Born into a wealthy family, Arbus took up photography when she and her husband started a photography business and were successful in the fashion world. Arbus later went her own way, shooting street photography.

Arbus used a Nikon 35mm then moved on to a Rolleflex TLR and a Mamiya TLR. Arbus was a prolific and received a Guggenheim Fellowship in 1963. She continued taking assignments from Esquire and other magazines. Arbus committed suicide in 1971 and was 48 years old.

Why I Like Diane Arbus

There's a deep sense of compelling prurience in Arbus's work, but also a deep sense of humanity. Arbus is not making fun of her subjects, she's acknowledging them as human beings. It's hard to look away from an Arbus image. Remember the twins in Stanley Kubrick's The Shining? If you've seen Identical Twins, Roselle, New Jersey you can see where Kubrick got the idea from.

Outstanding Photographs
Identical Twins, Roselle, New Jersey. (This is commonly know as the "Arbus Twins")
Child with Toy Hand Grenade in Central Park
Female Impersonators
Lady on a Bus

Henri Cartier-Bresson

Henri Cartier-Bresson was born in France in 1908, and like Stieglitz and Arbus, born into a wealthy family. Cartier-Bresson started out as a painter then was drawn to a photographic surrealist movement emerging in France. He was one of the founders of Magnum Photos, of which W Eugene Smith was associated with much later.

Cartier-Bresson shot with a Leica 35mm rangefinder with a 50mm lens, and not much more.

Why I Like Henri Cartier-Bresson

The first time I saw a Cartier-Bresson was at the Detroit Institute of Arts. The photograph was Hyeres, France, 1932. I stared at it for about fifteen minutes, wandered around the museum, then came back to it twice. It's one of my all time favorite photographs, how the stairs spiral down to the man speeding on the bicycle. Cartier-Bresson is a master of instantaneous composition, and we as photographers can learn a great deal from him. Armed with a simple 35mm rangefinder and a 50mm lens, not much more is needed to produce great art. Translated to medium format, this is a TLR or SLR with an 80m lens. Henri Cartier-Bresson died in 2004 in France.

Outstanding Photographs
Hyères, France, 1932
Nehru Announces Gandhi's Death
Sumatra, Indonesia, 1952
To Tell the Truth, New York, 1959

Robert Frank

Robert Frank, best known for the book The Americans, was born in in Switzerland in 1924. He emigrated to the United States in 1947 where he shot fashion for Harpers Bazaar. During the many road trips Frank took he shot around 28,000 exposures. Frank used a Leica III rangefinder along with 35, 50, and 90mm lenses. From pre-teen Lolitas with dangling cigarettes from their lips to starlets at Hollywood movie premiers to working class lunch counters in Detroit, Robert Frank captured America and its diverse, arid everyday life.

Why I Like Robert Frank

There's a rawness about Frank's work, and an uncanny ability to capture cultural and economic diversity in a single image. Frank lacks the prurience of Diane Arbus and is more objective, which I believe give his images a wider appeal. Each Robert Frank image sends a message, and it's not always good.

Outstanding Photographs
Butte, Montana, 1955
Parade, Hoboken, New Jersey 1955
Indianapolis, 1956
Sagamore Cafeteria, NYC, 1954

Man Ray

Man Ray, born in South Philadelphia in 1890. He was driving photographic force behind the Dada and Surrealist movements in the early Twentieth Century. Ray started out as a commercial artist and a technical illustrator. Deeply involved in the emerging Data movement, Ray relocated to Paris where his real focus on photography began. Ray flip-flopped between painting and photography, as illustrated in this quote, "*I paint what cannot be photographed, that which comes from the imagination or from dreams, or from an unconscious drive. I photograph the things that I do not wish to paint, the things which already have an existence.*" Man Ray was also the inventor of the photographic technique "solarization", which nowadays is a standard filter, although a bit dated. I'm not sure what Ray used, but I read somewhere he had a 4x5 rangefinder. Ray died in Paris in 1976.

Why I Like Man Ray

There's a underlying sensualism and eroticism in Man Ray's work that shines through in almost every one of his portraits. I admire the toggling between painting and photography which I believe are joined at the hip. Man Ray was always on the edge of art, and never really played it safe.

Outstanding Photographs

Selma Browner, 1940

Kiki, 1927

Ev La Tour, 1930

Terrain Vague, 1929

Ansel Adams

The polar opposite of a street or abstract photographer, Ansel Adams, the premier American landscape photographer, was born in 1902. He is most well known for his landscapes of Yosemite National Park. An talented piano player since his youth, he broke away from music and turned to photography. For us as photographers, he greatest gift is the Zone System, which we briefly covered. Adams did not singularly develop the Zone System. Photographer Fred Archer, a contemporary and associate of Adams, co-invented the Zone System, which Adams went to pains to acknowledge. Adams died in California in 1984.

Ansel Adams also wrote for definitive references regarding his style of photography:

- Book 1 Camera & Lens
- Book 2 The Negative
- Book 3 The Print
- Book 4 Natural-light Photography
- Book 5 Artificial-light Photography

These books, packed with technical detail, are well worth studying.

Why I Like Ansel Adams

Aside from his stunning and master crafted black and white images of Yosemite, Adams helped photographers to truly visualize in image an black and white. Utilizing the Zone System, even partially, is a gift to black and white photographers world-wide. Photographers can learn volumes just by looking at one Adams print.

Outstanding Photographs
Aspens, Northern New Mexico
Rock Creek Canyon
Ice on Ellerly Lake
Mormon Temple, Manti, Utah

Standing on the Shoulders of Giants

As medium format black and white film photographers, we gratefully stand on the shoulders of these giants. Again, this is a microscopic list of great black and white photographers. Yes, some of them shot with 35mm and large format view cameras, but great is great and it's more about the final image than equipment. I study the great black and white photographers all the time and intend to do so for the rest of my days.

Final Thoughts

It is my sincere hope that this little book inspires you in some way to take up medium format black and white film photography. It's a wonderful art form that never gets tiresome. If you decide to dive in, you are entering a two hundred year old artistic tradition that is humbling and exciting. Once you get the basics down, such as exposure, composition, visualization and negative development you can take the first steps in producing art. It's a lifelong, rewarding process and the more you learn, you realize the less you know. That's one of appealing aspects.

I like this Charles Bukowski quote, and I think applies to photographers: *"An intellectual says a simple thing in a hard way. An artist says a hard thing in a simple way."* These are good words to live and shoot by. We as medium format film photographers aspire to art, and it is our hope and intent to express complex, powerful emotions in our simple images.

About the Author

Jeff Stefan is the principle photographer and videographer at **J Stefan Photography,** based in Southeastern Michigan. Jeff is the author of **Exploiting Your Point and Shoot, The Essentials of 35mm Film Photography, Urban Photography Using Small Digital Cameras** and **The DSLR Artist,** all available on Amazon.com.

www.ingramcontent.com/pod-product-compliance
Lightning Source LLC
Chambersburg PA
CBHW020558220526
45463CB00006B/2353